Dedication:

For my wonderful huband,
Dave, the love of my life, who has supported my art
and put up with my many hairbrained ideas
for so many years.

Thank you Love

On The Cover:
"It's In The Kitchen"

How to enjoy your mandala book

"Fun With Mandalas" is a coloring book for all ages. There are simple mandalas for those who want larger areas to color and more intriciate mandalas for those who love a challenge.

You can use any medium of color you choose, crayons, colored pencils (I use Primascolor, but there are many brands out there that are good pencils), markers, pastels, etc.

Simply go to the index in the back of the book and select a title that intrigues you or flip through the pages and find a design that tickles your fancy.

Once you have chosen one to color, be sure to put a heavy piece of paper underneath it to preserve the mandalas underneath from indentations caused by pressure with pencils or crayons.

Next, choose your first color or chose a range of colors and begin.

There is no wrong or right in how you color your mandalas. Just use your imagination and have fun!

And the fun begins:

(Facing Page)
Flower Power

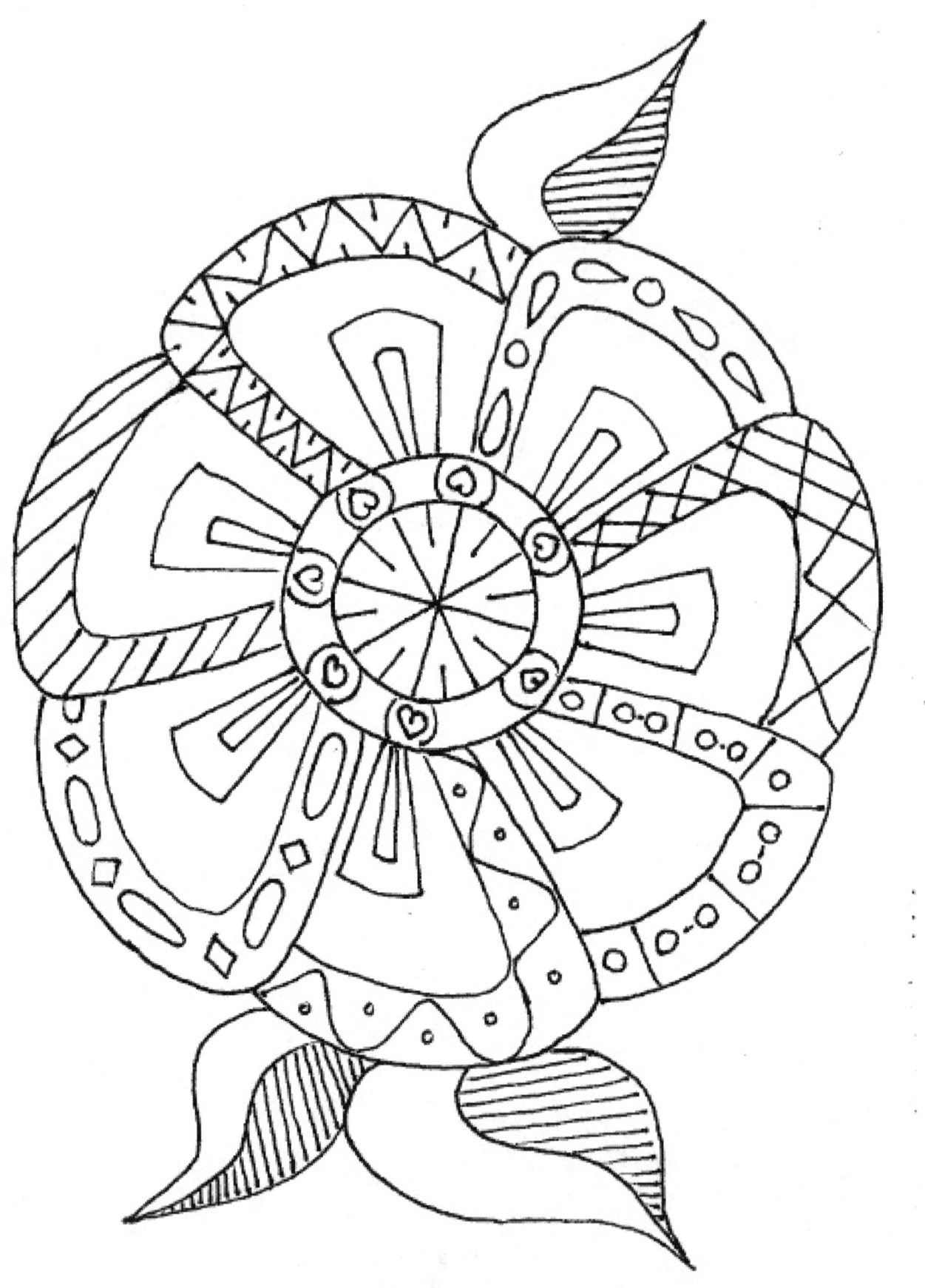

Facing Page:
"It's Gonna Leak"

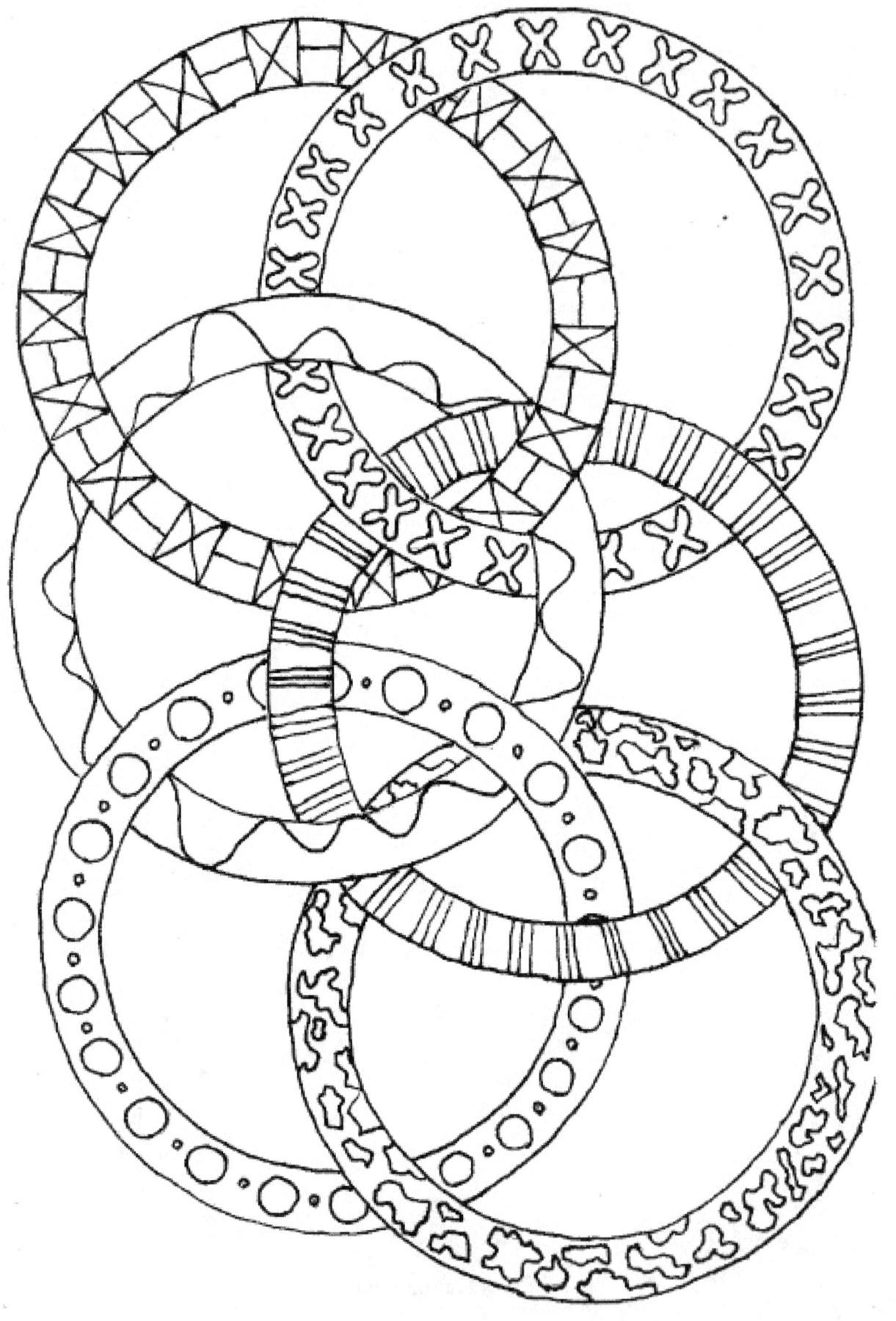

**Facing Page:
"Wishing Well"**

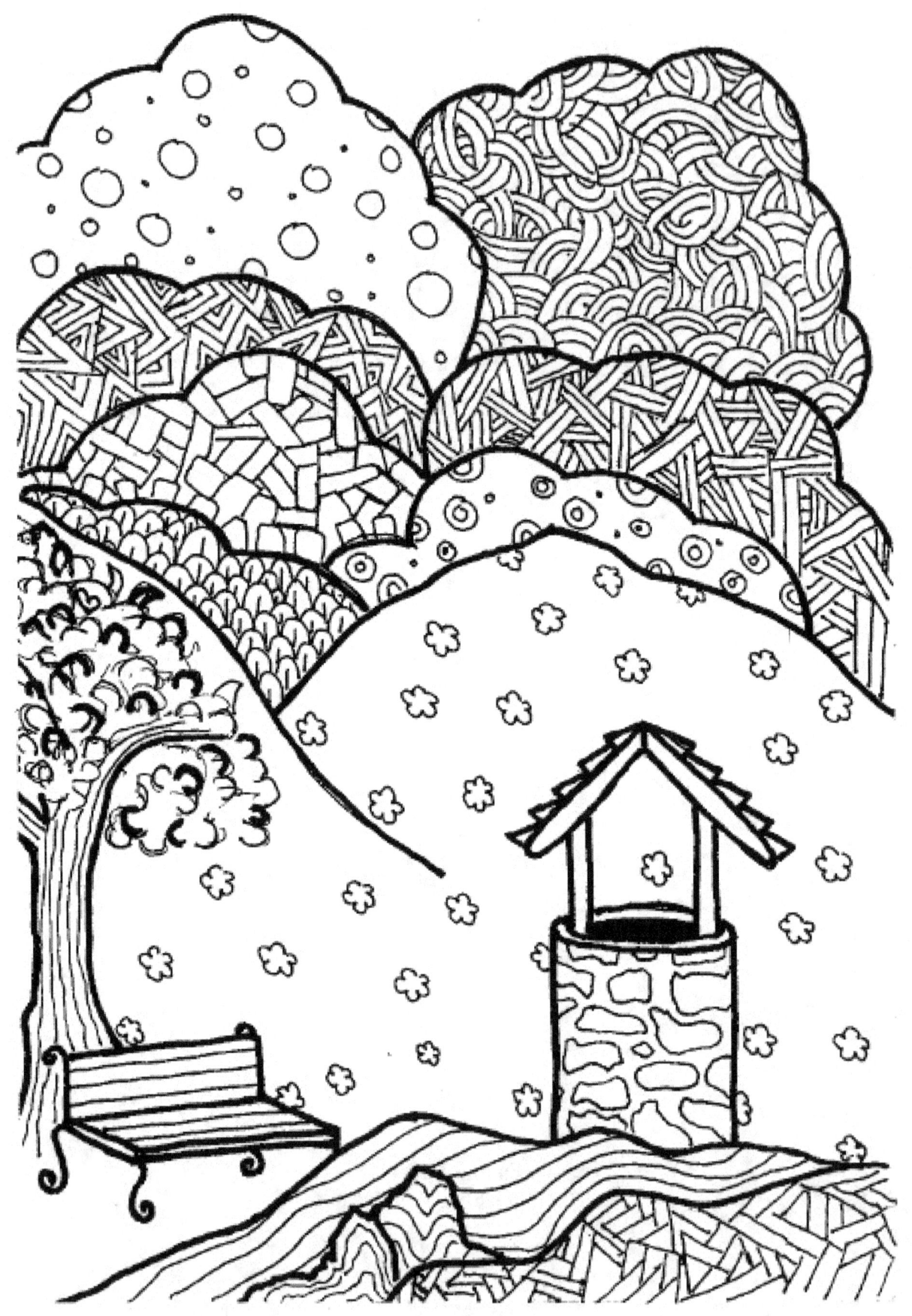

**Facing Page:
"Tricycle"**

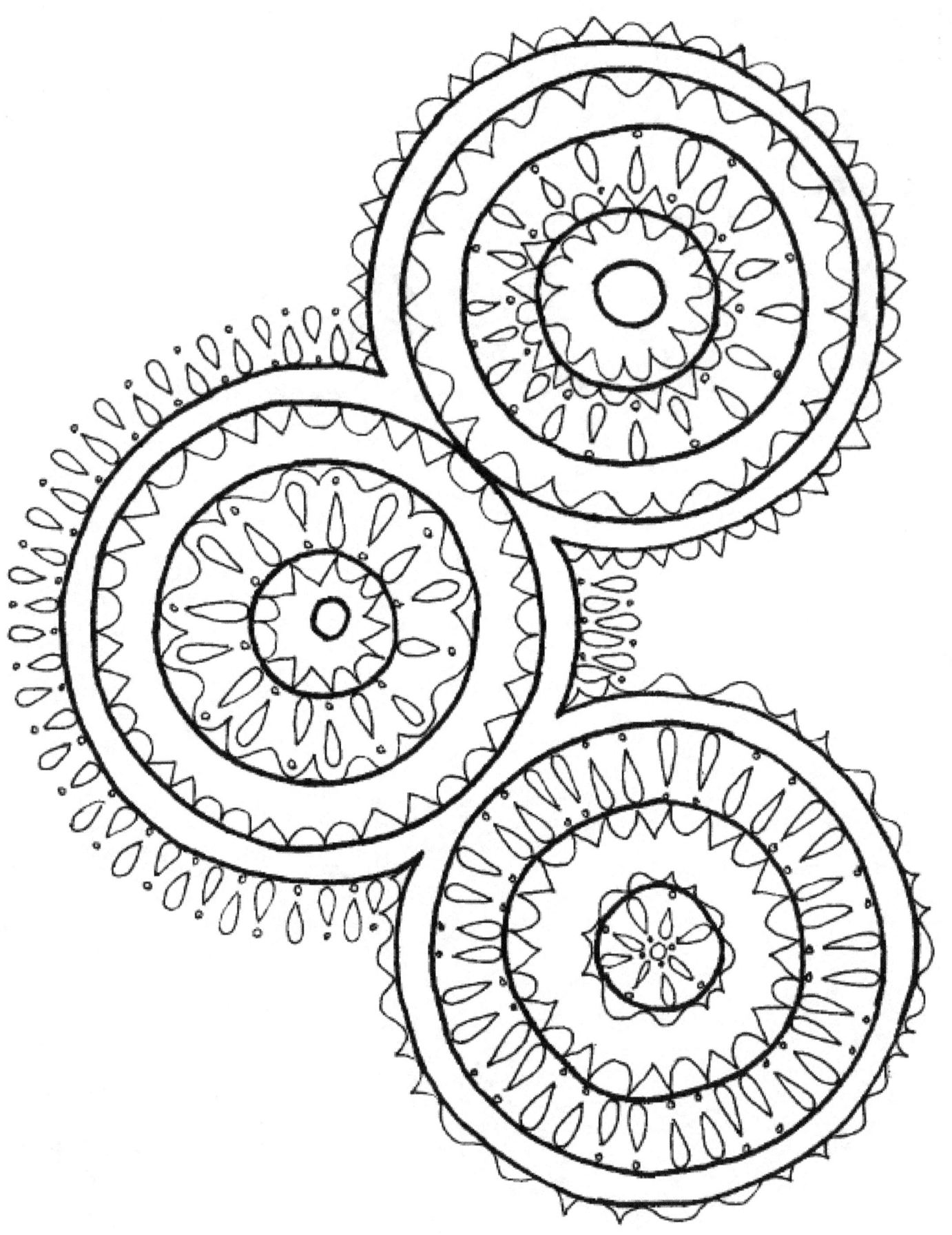

**Facing Page:
"Kalaidascope"**

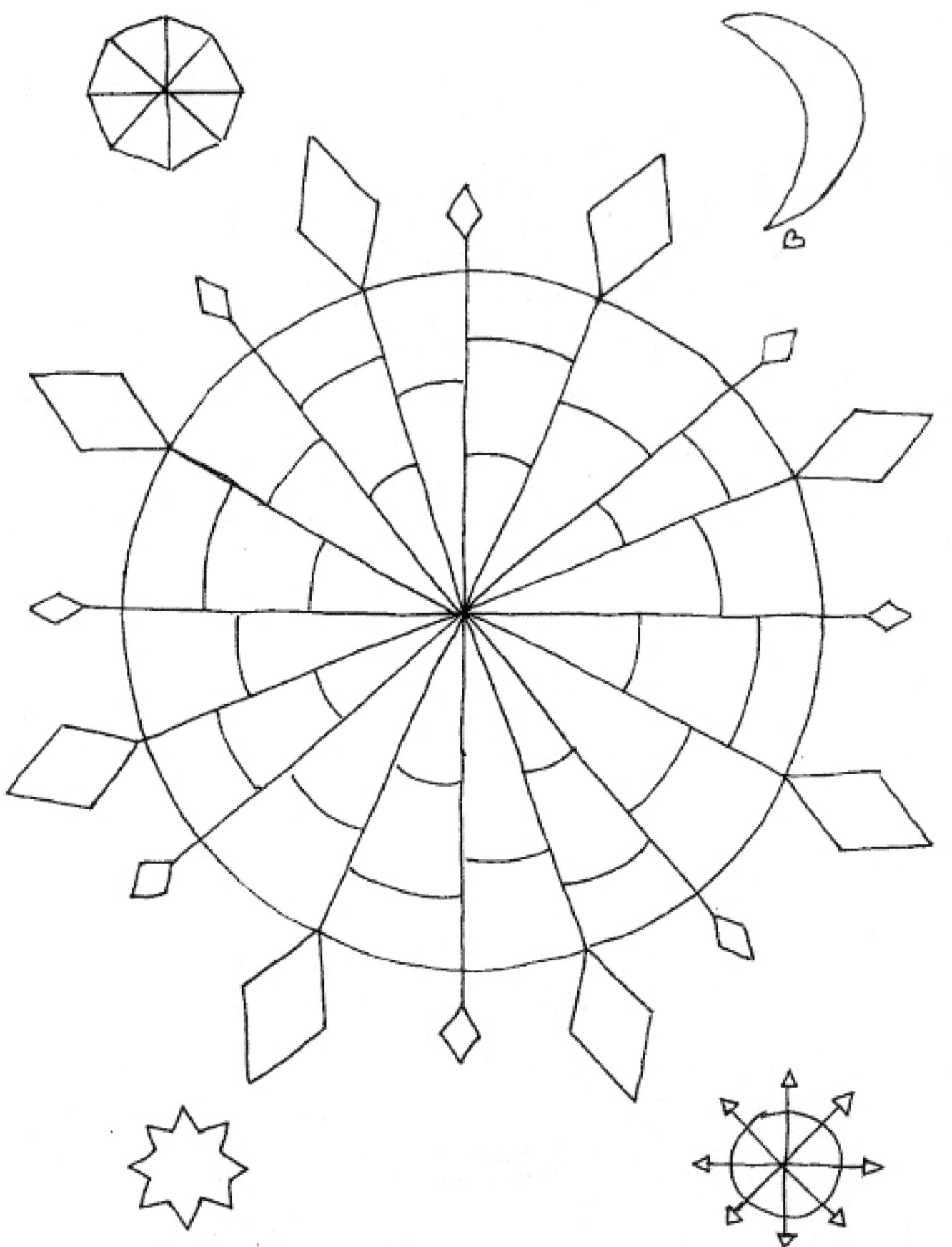

**Facing Page:
"It's In The Kitchen"**

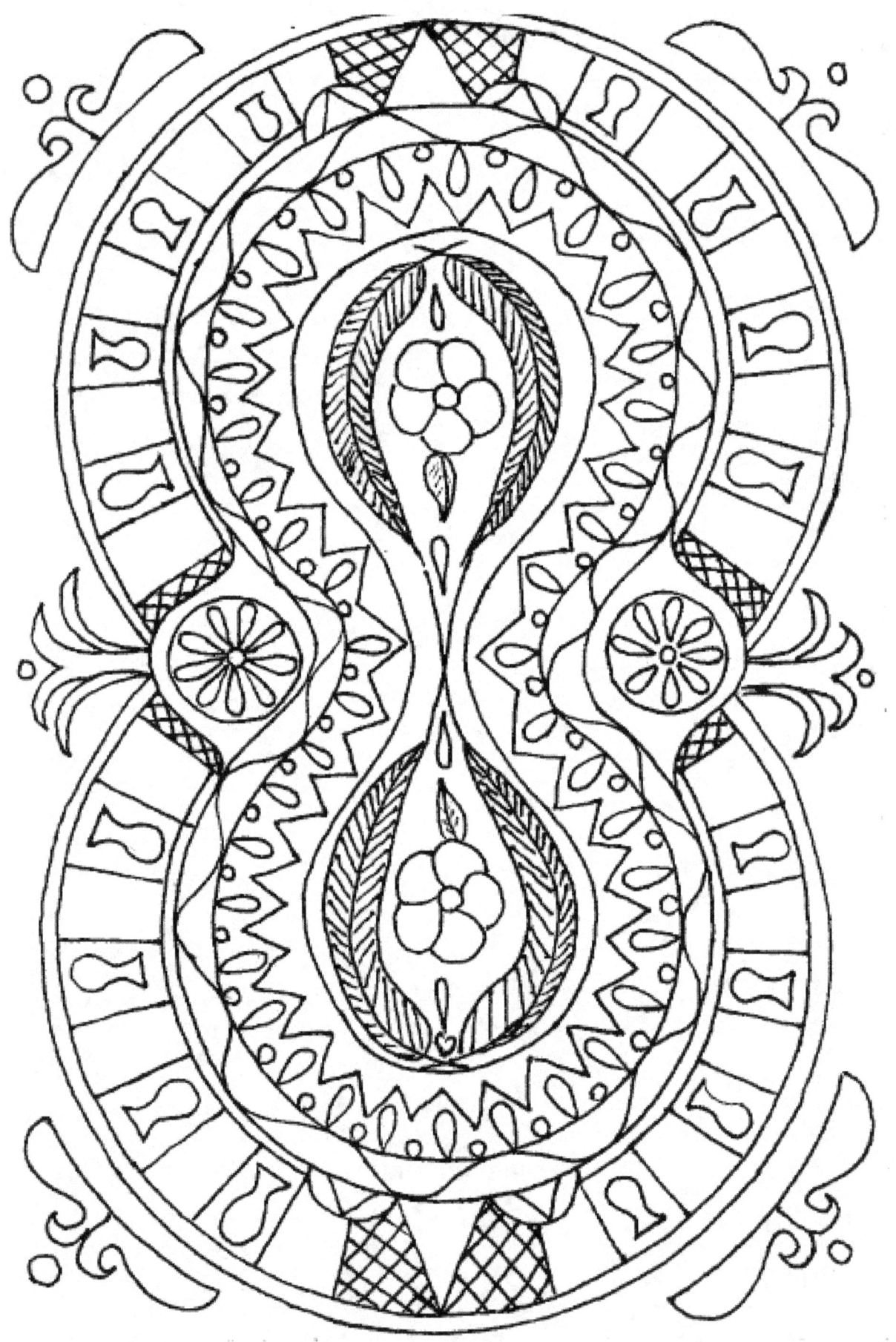

**Facing Page:
""Sea Life"**

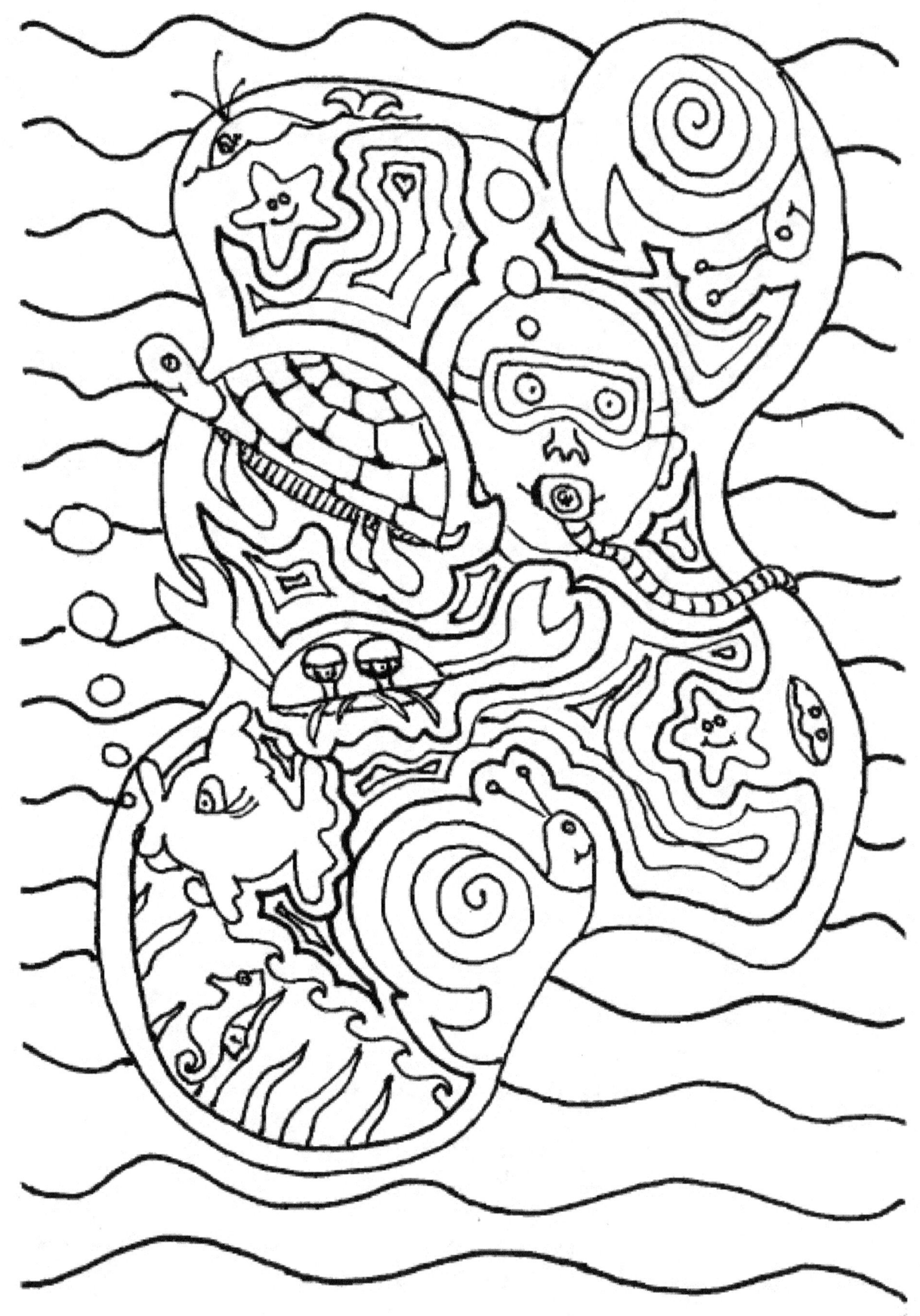

**Facing Page:
"Daisies On Parade"**

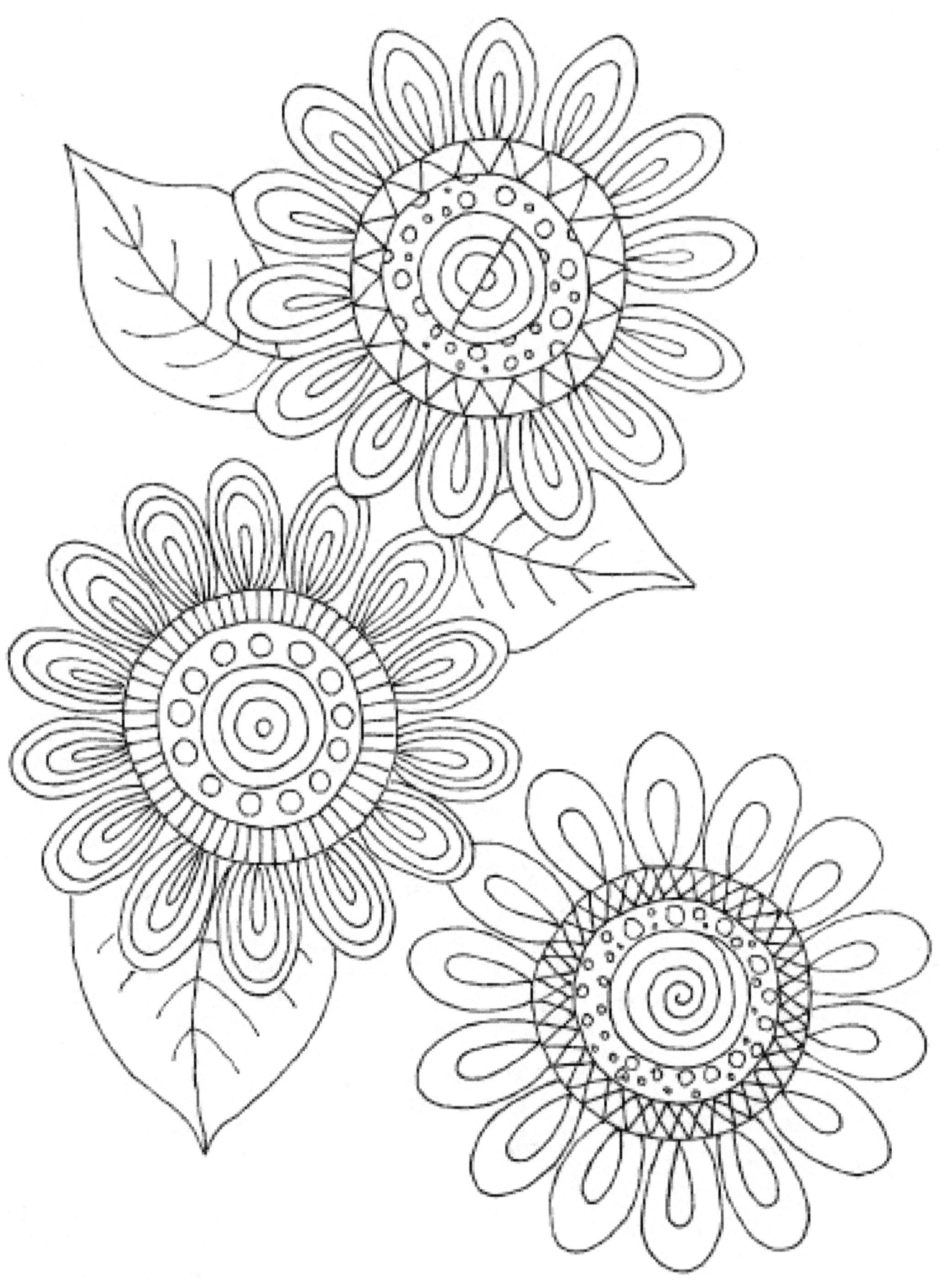

Facing Page:
"Sound Bounces"

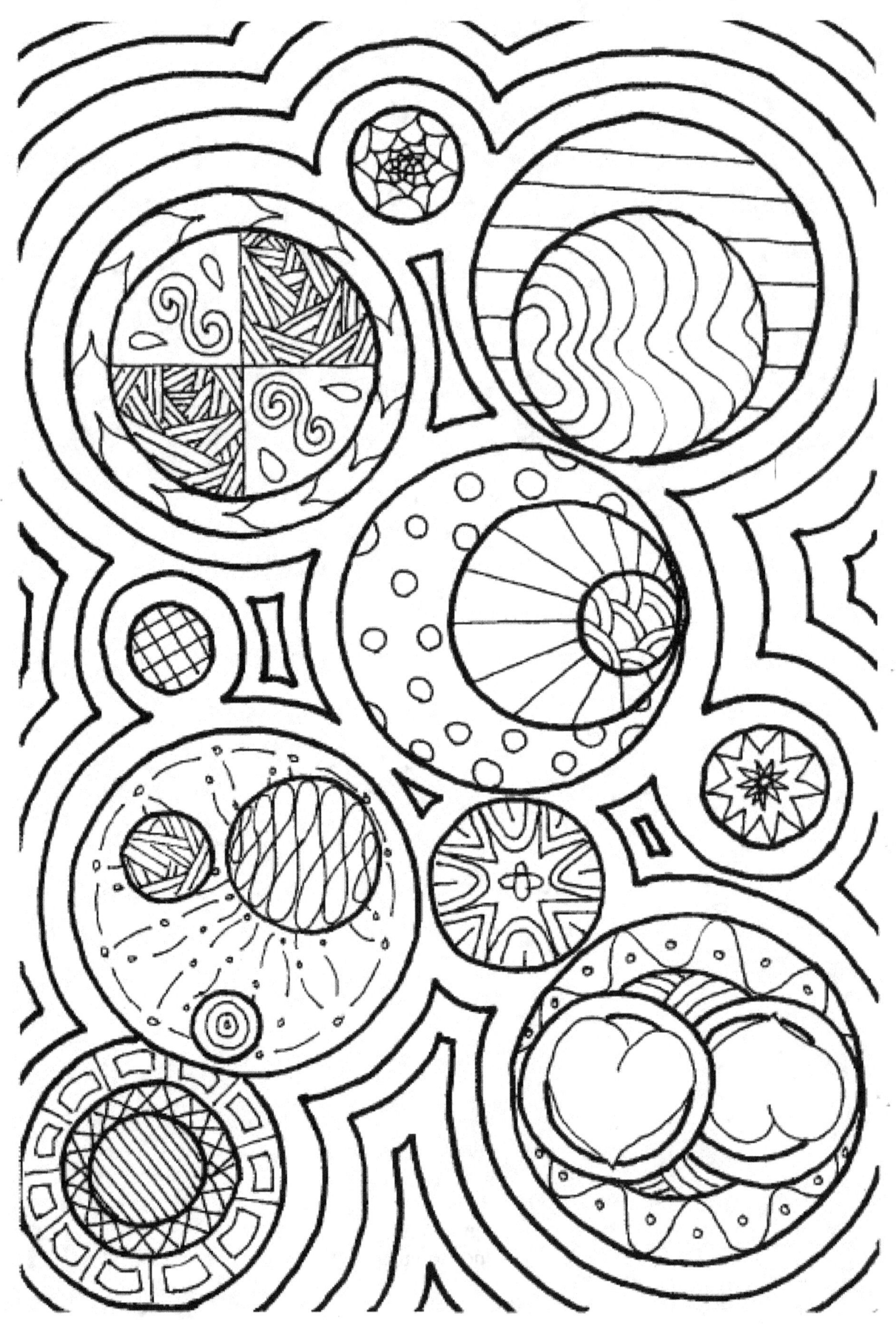

Facing Page:
"Bella"

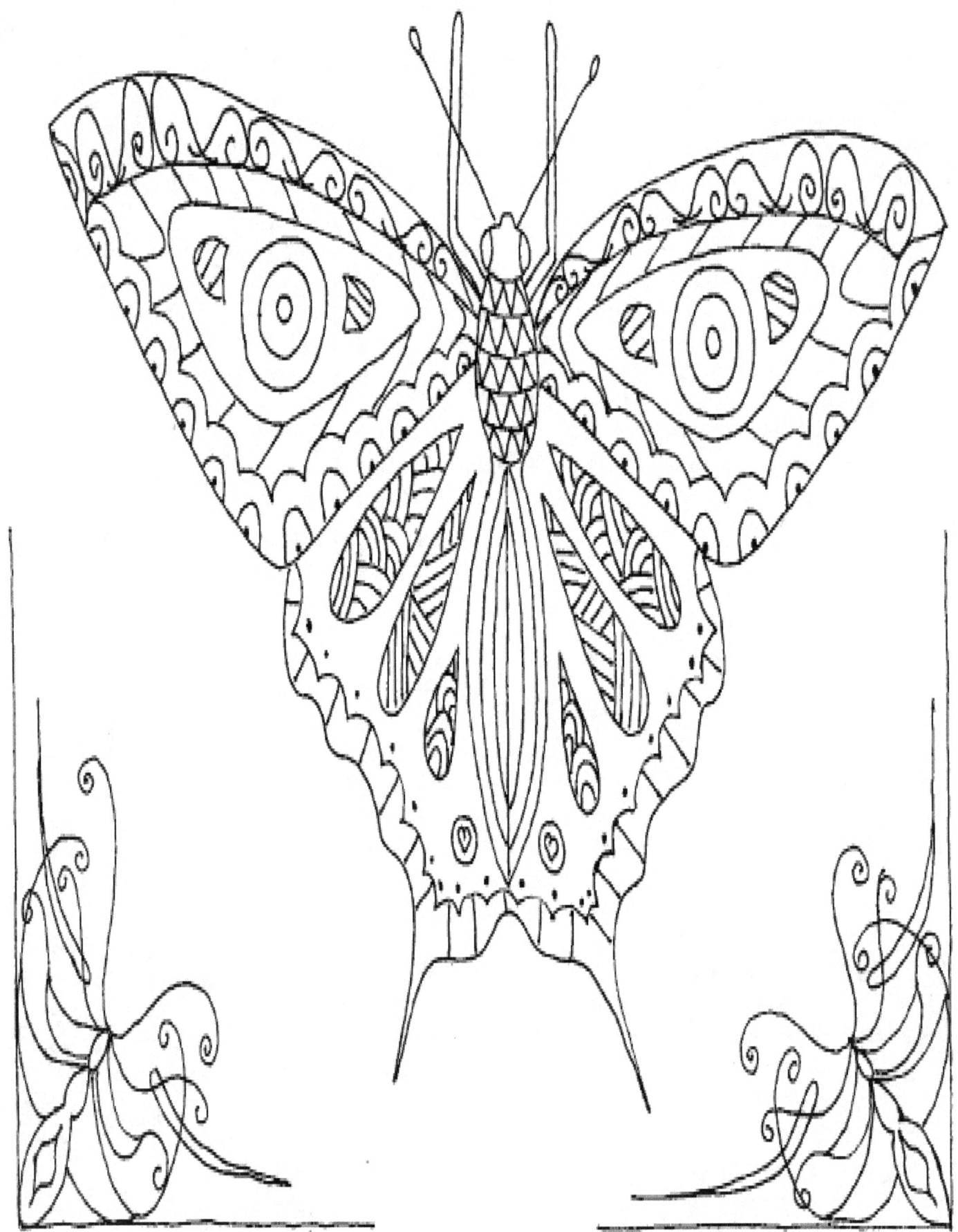

Facing Page:
"Love Locked"

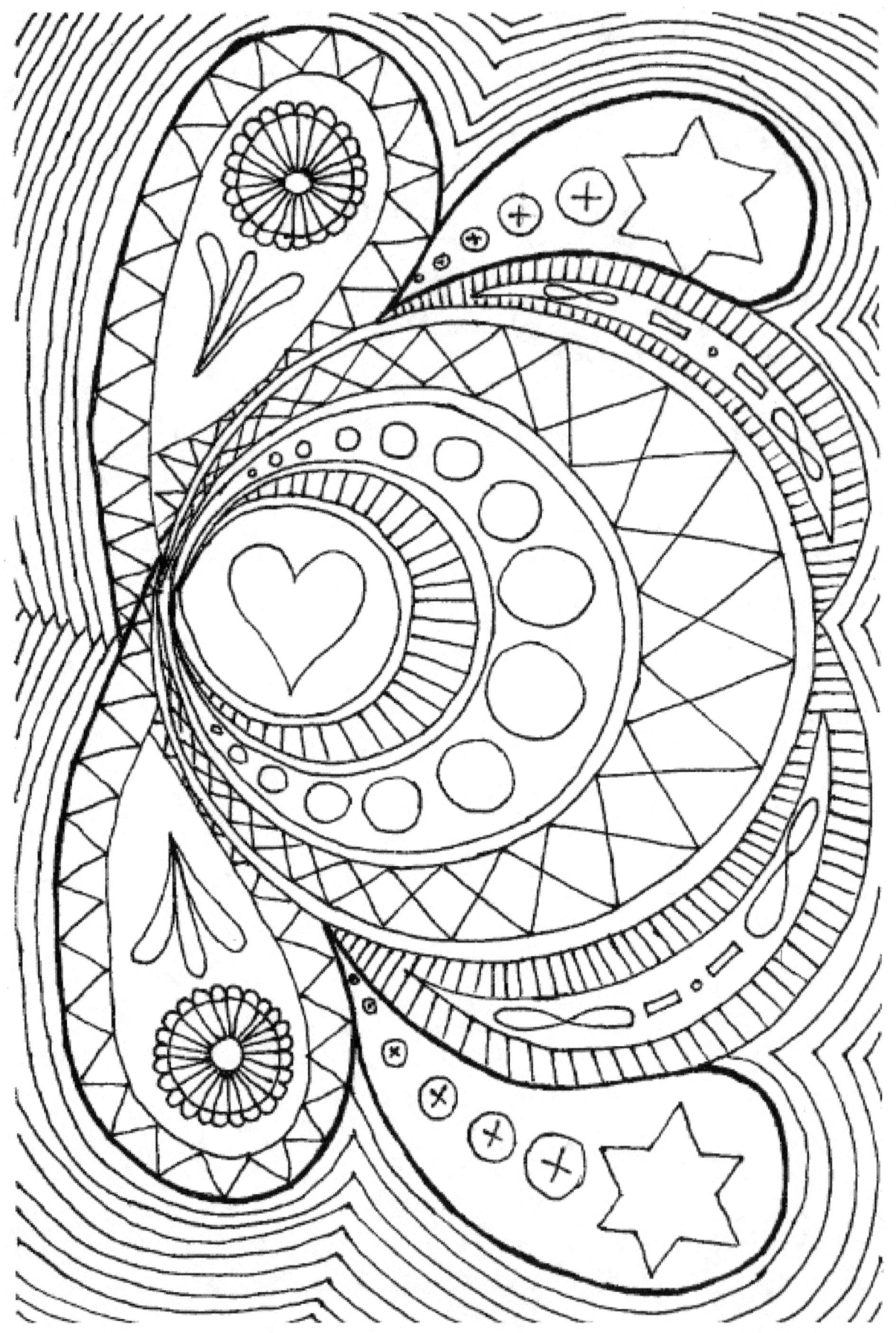

Facing Page:
"Plumeria"

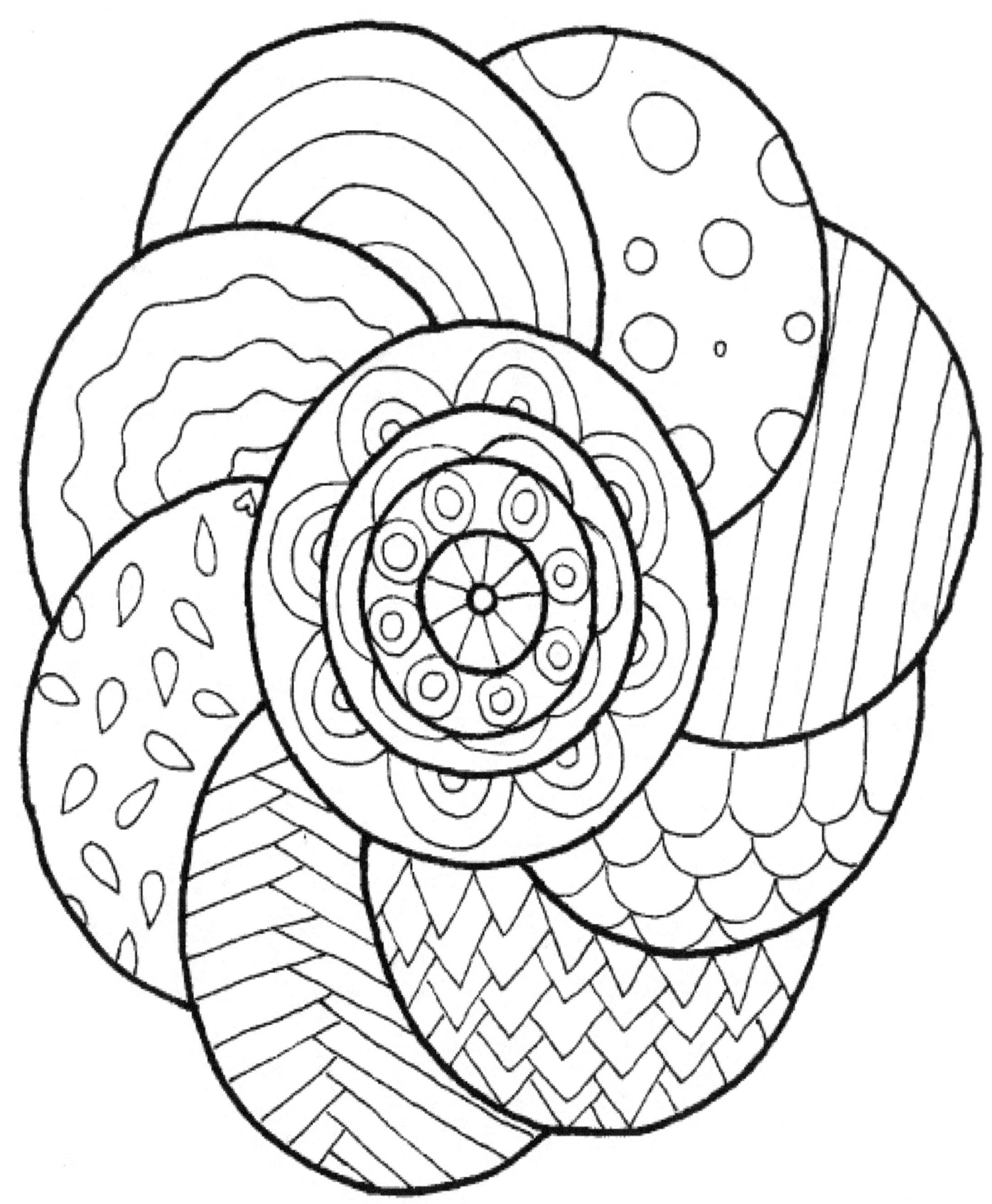

Facing Page:
"Test Pattern"

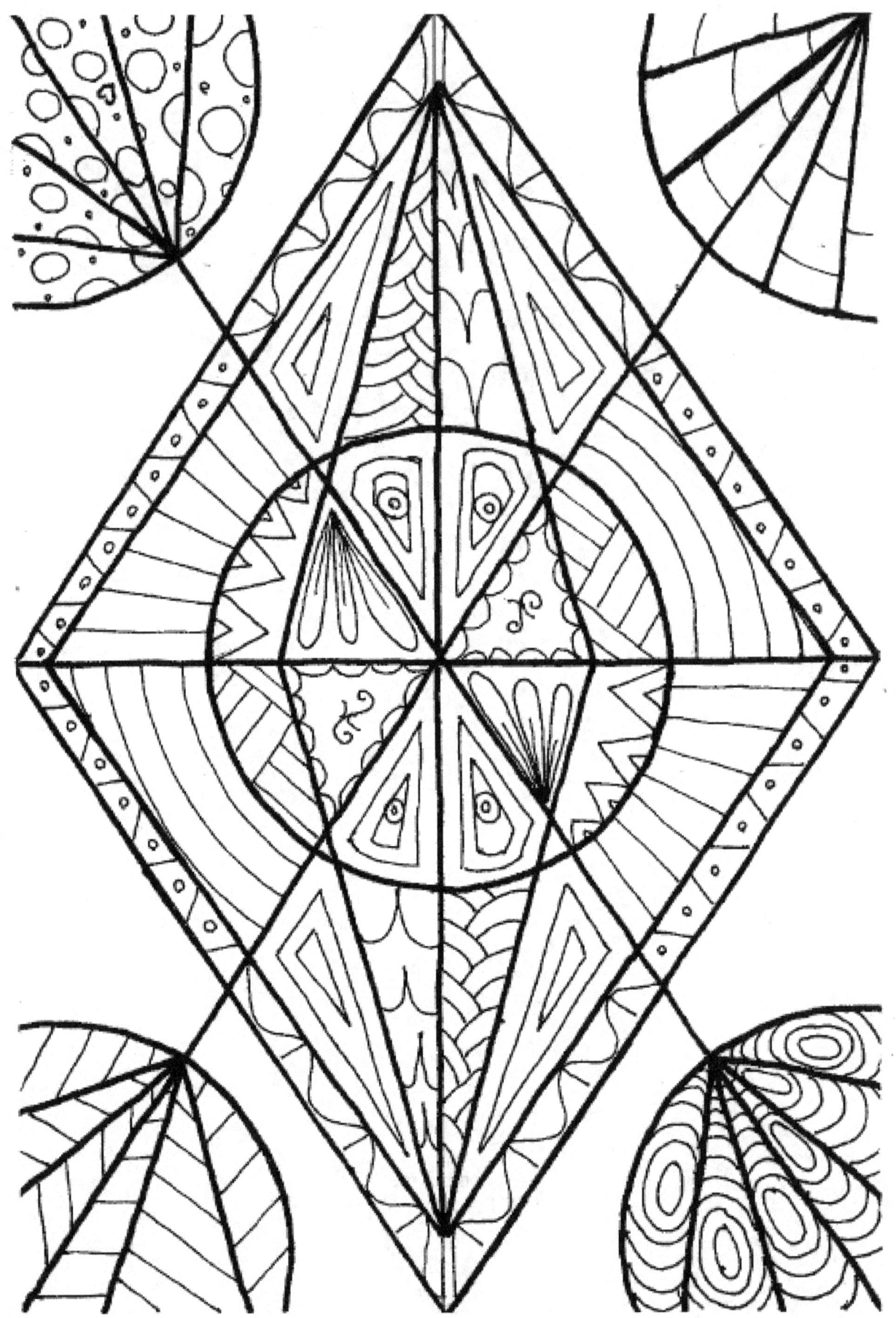

Facing Page:
"Too True"

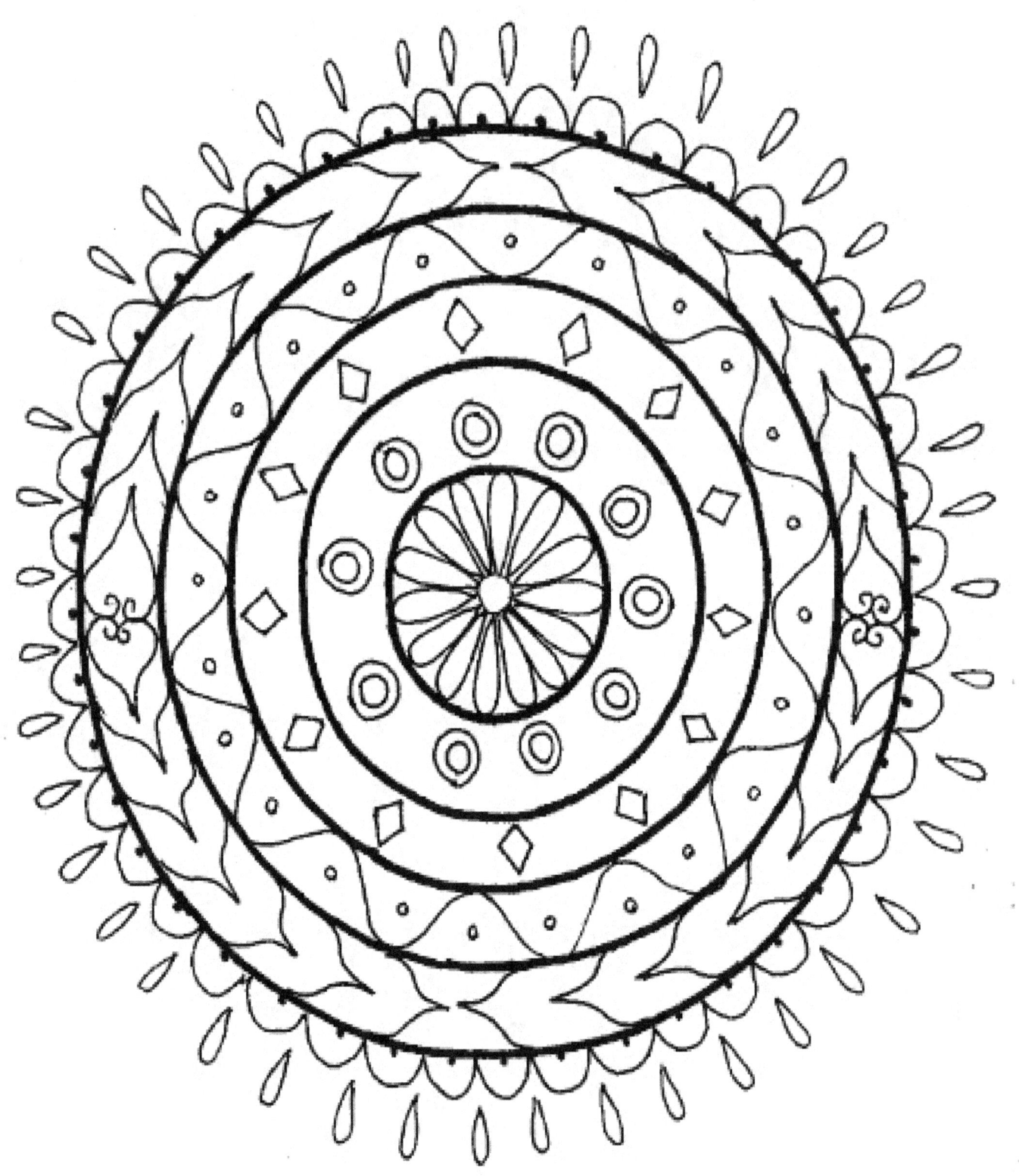

Facing Page:
"Dual Waterfalls"

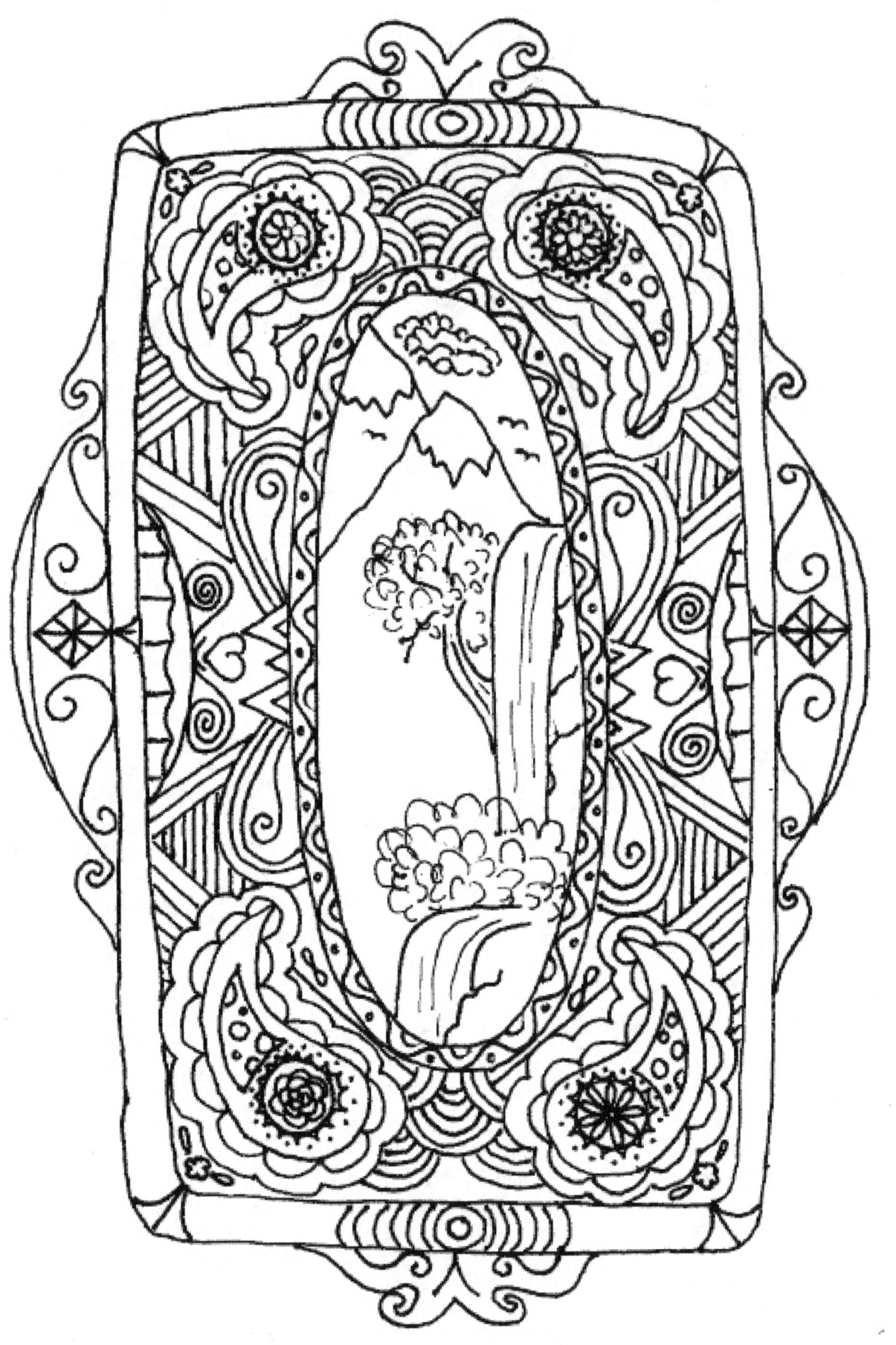

Facing Page:
"With A Cherry On Top"

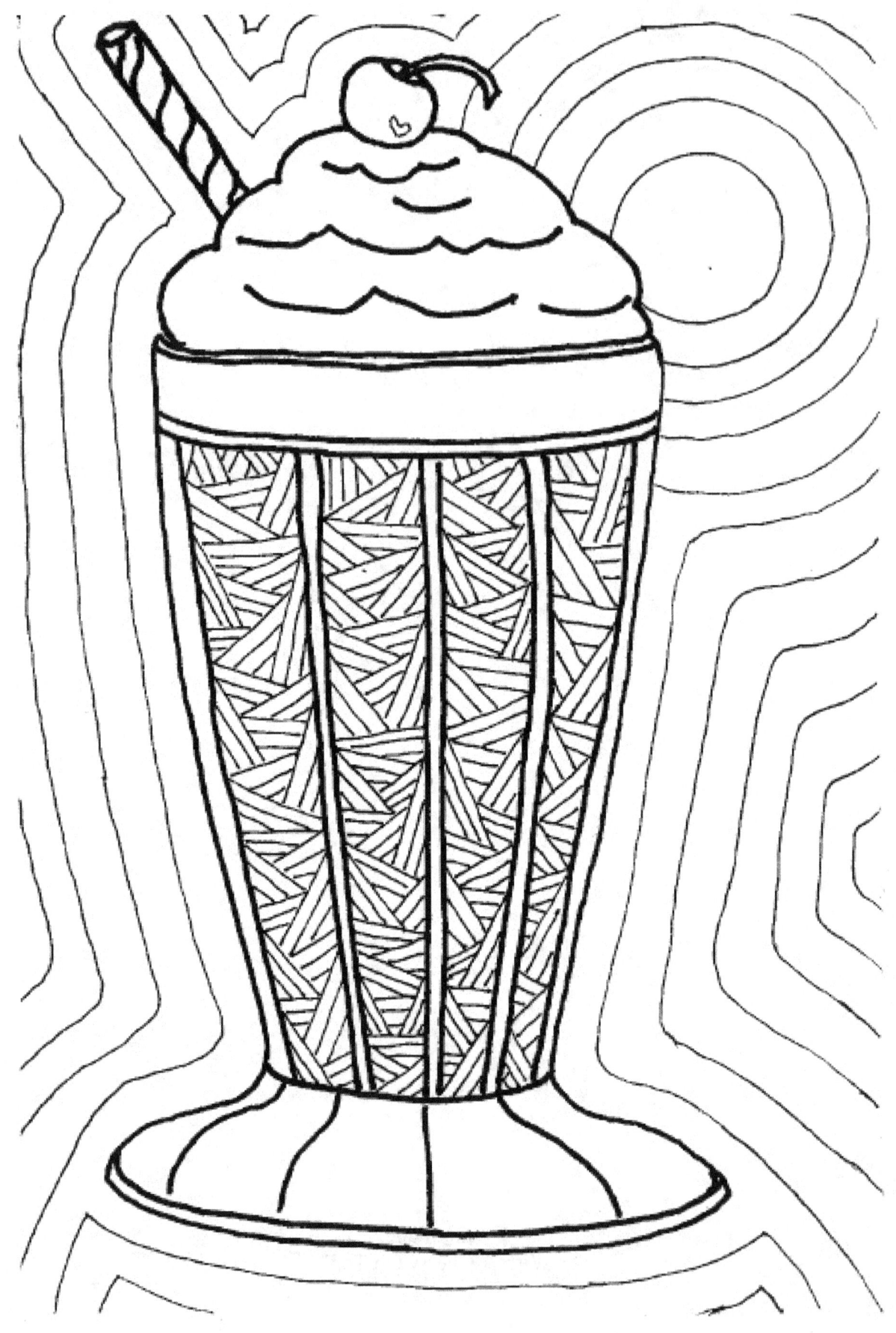

Facing Page:
"Night And Day"

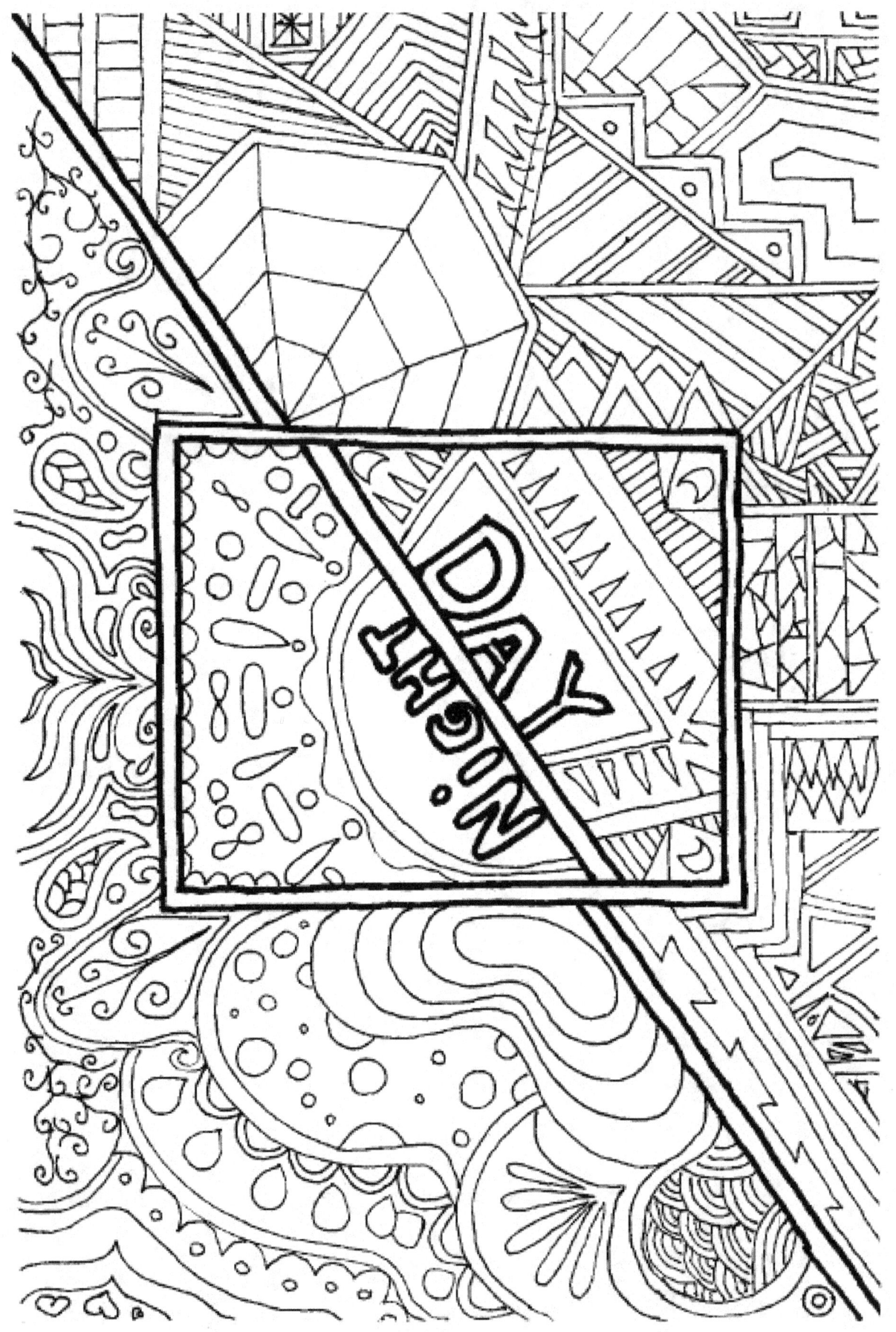

Facing Page:
"Playful Assymetry"

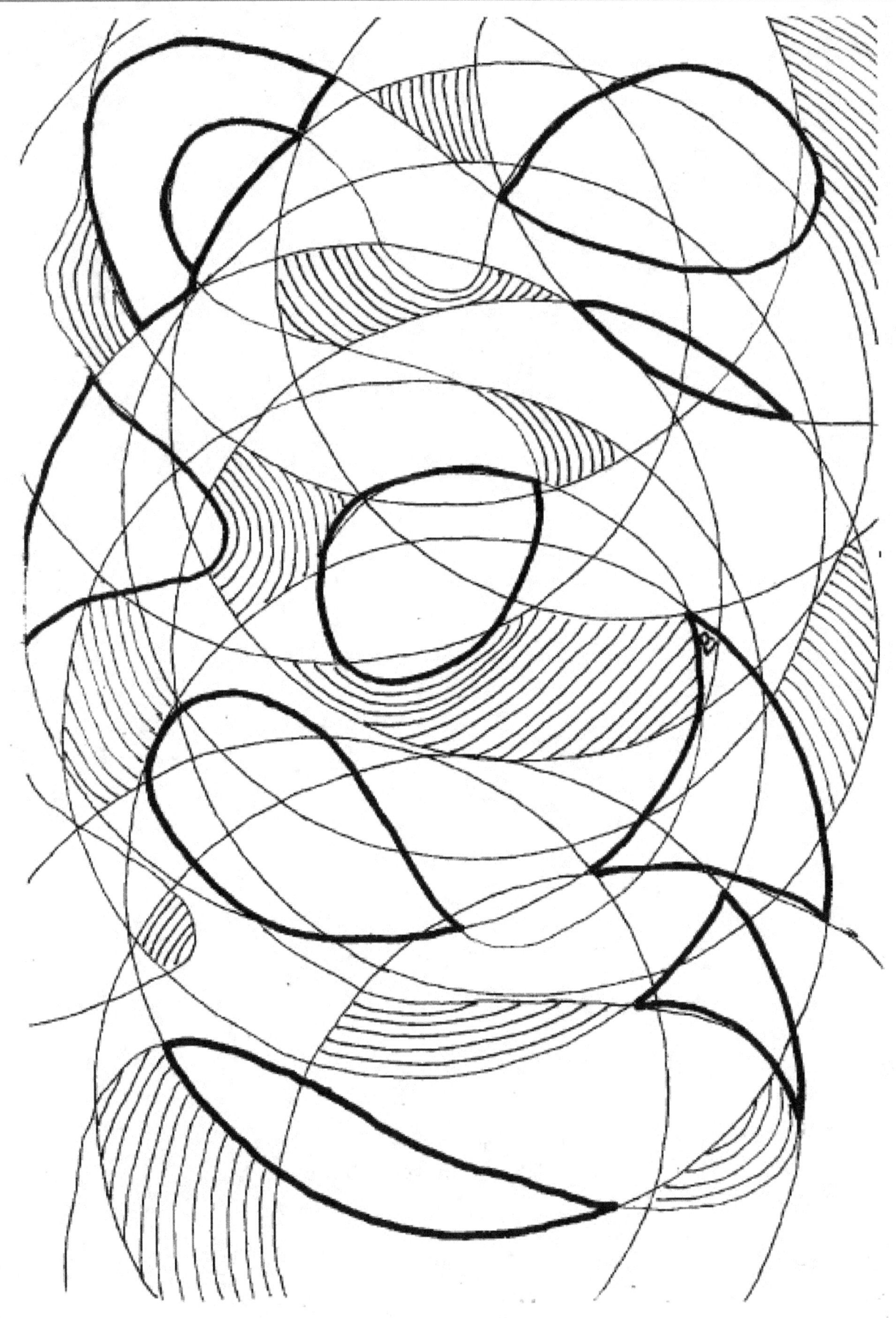

Facing Page:
"Shroomage"

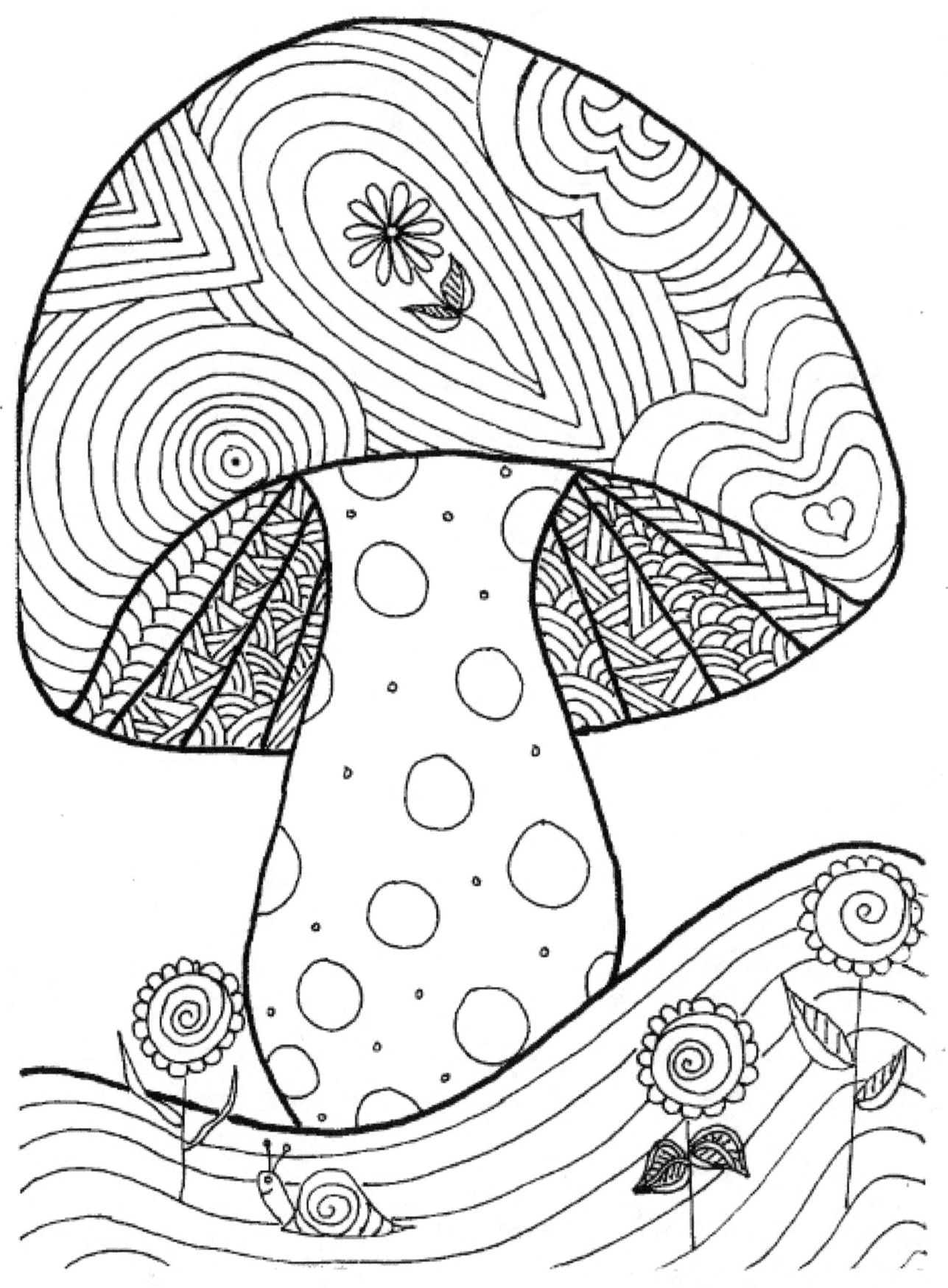

Facing Page:
"Flower Garden"

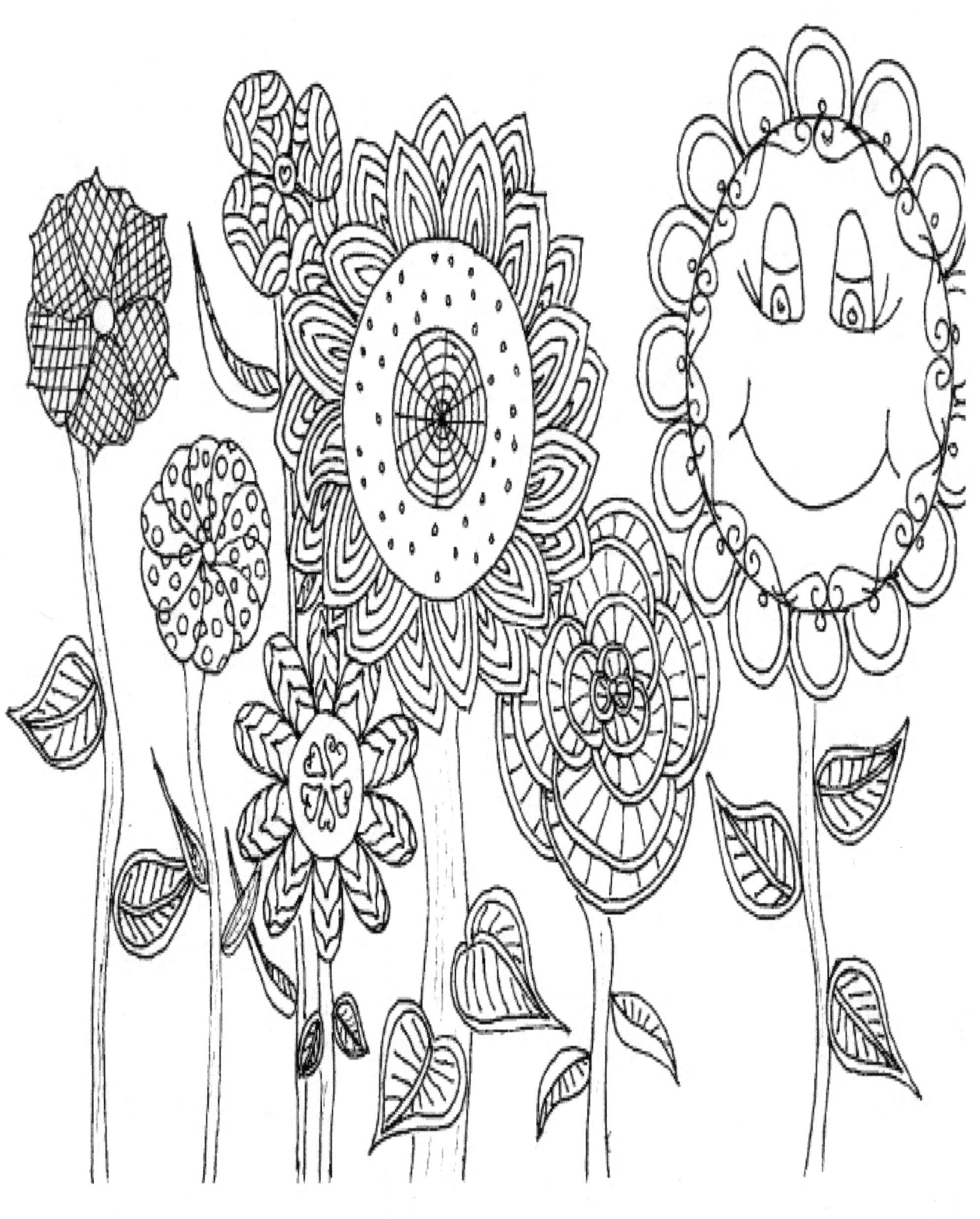

Facing Page:
"Sunflower"

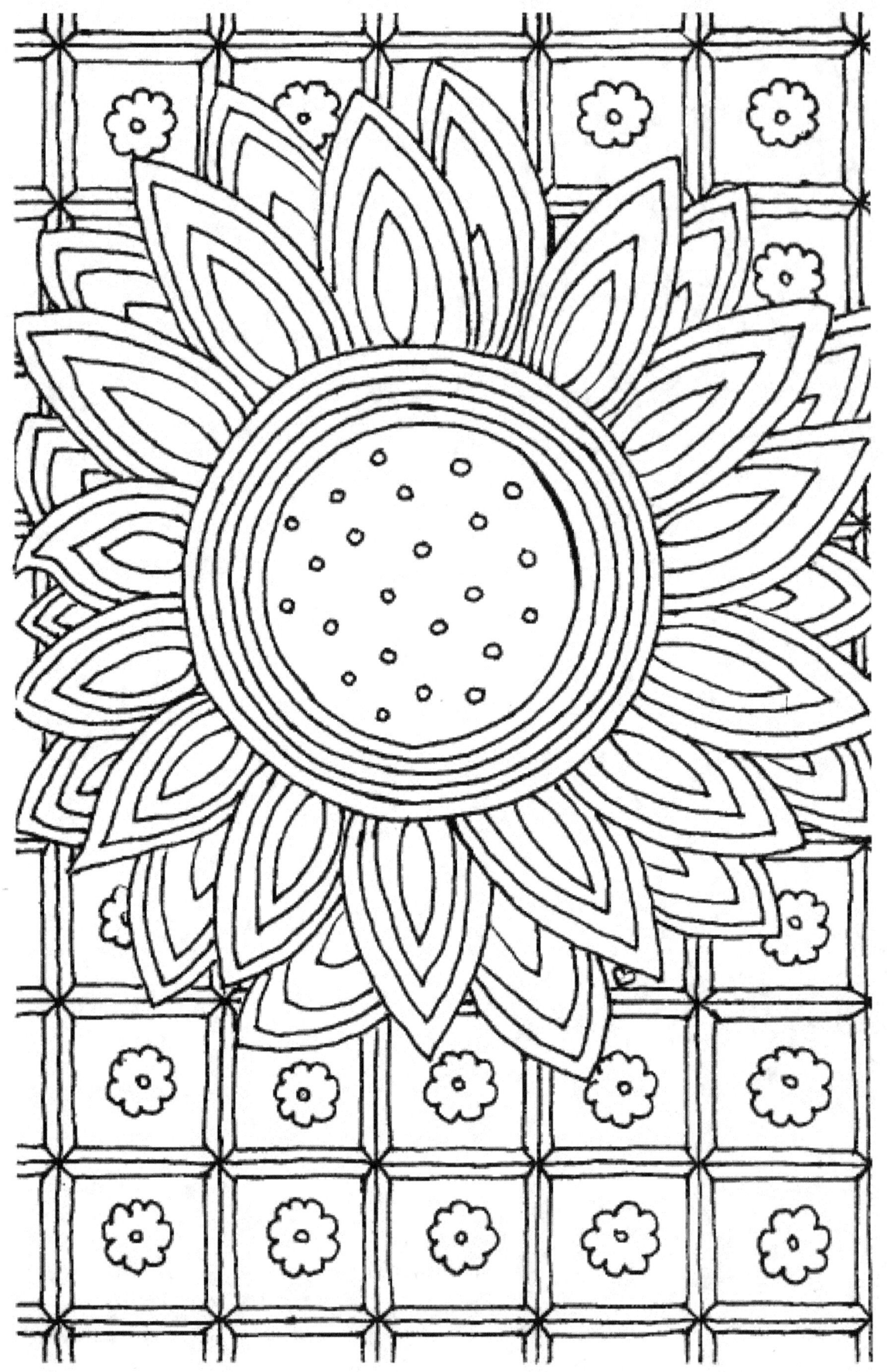

Facing Page:
"Bubbles, Bubbles, Bubbles"

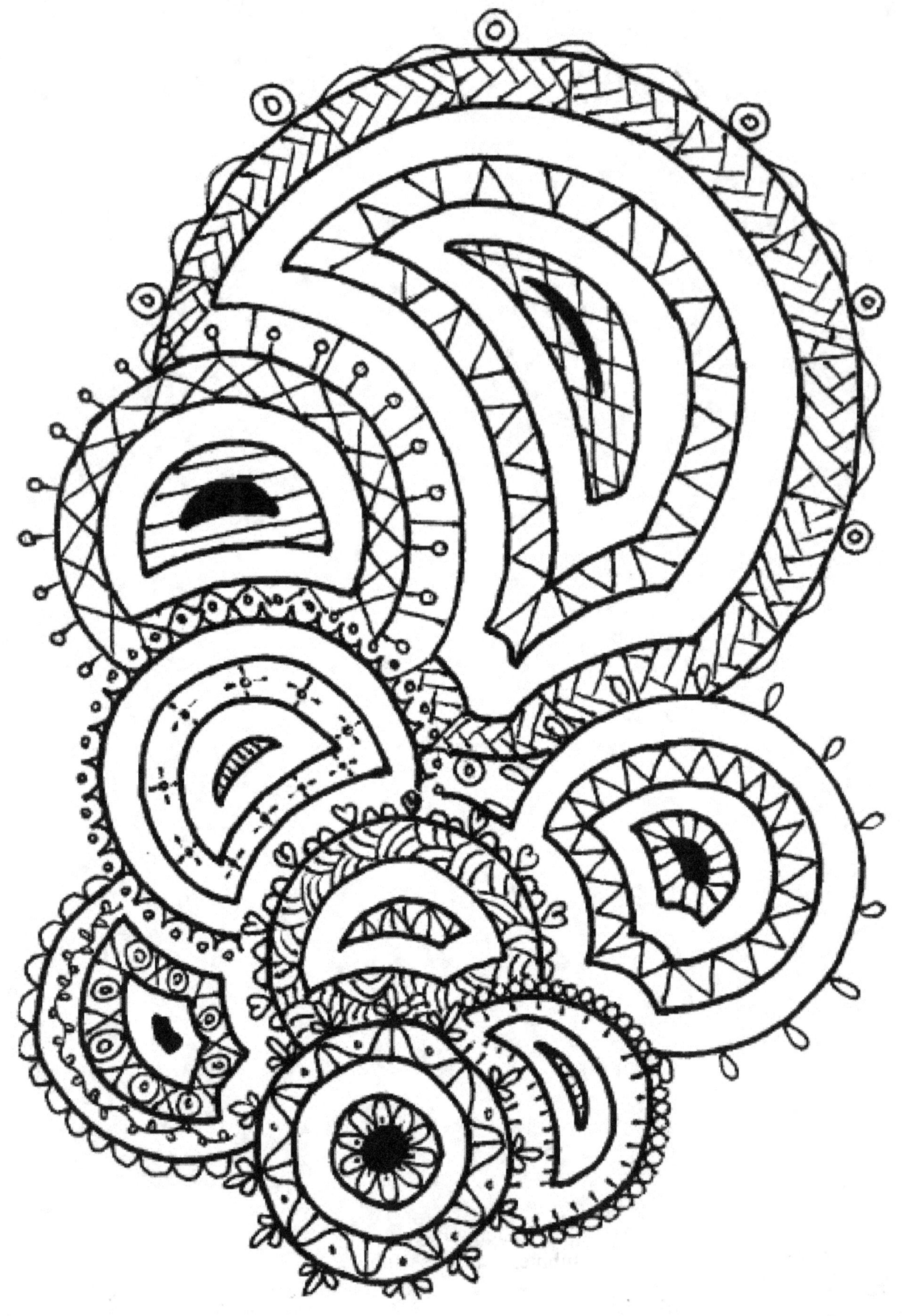

Facing Page:
"Crossed Diamonds"

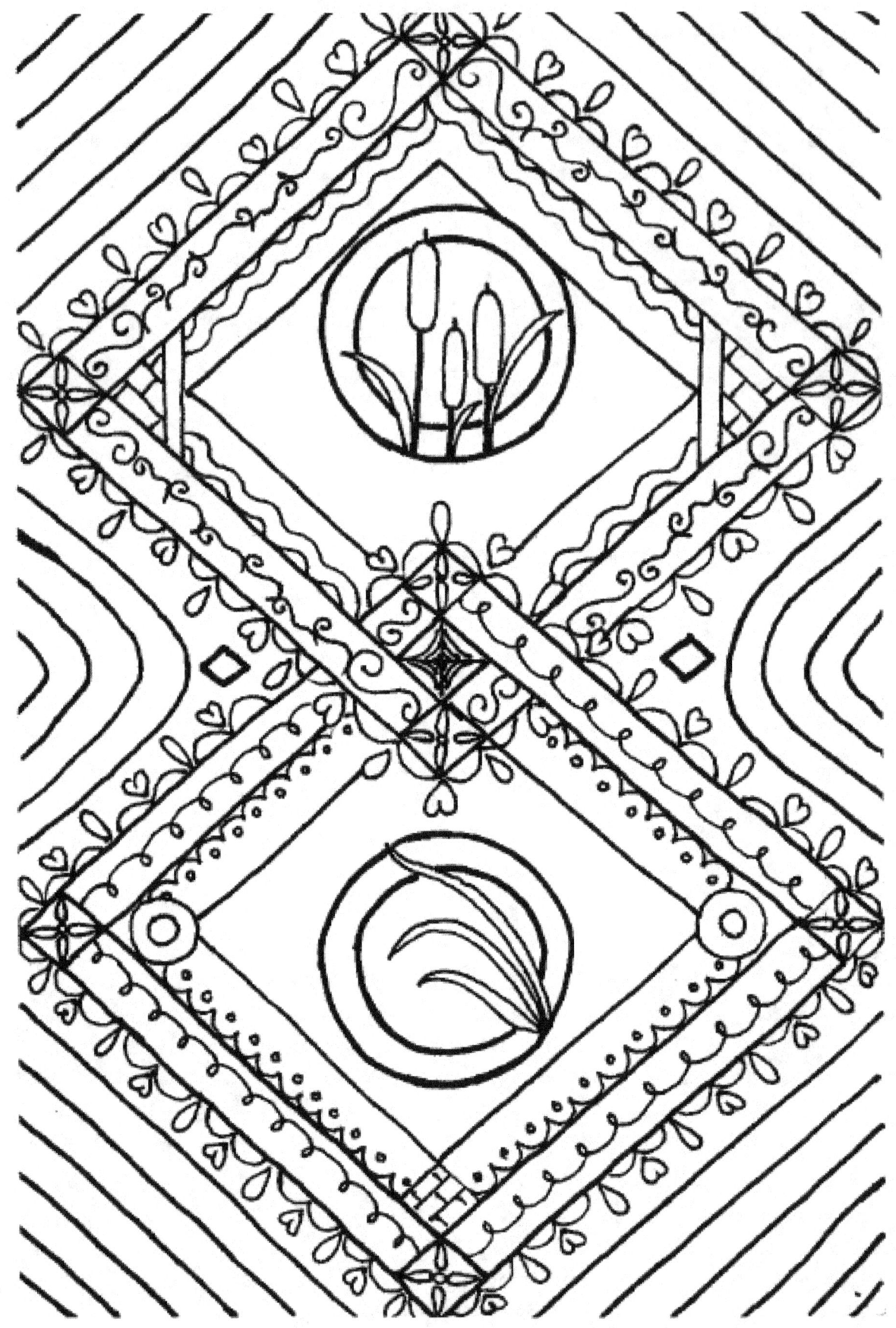

Facing Page:
"A Day At The Beach"

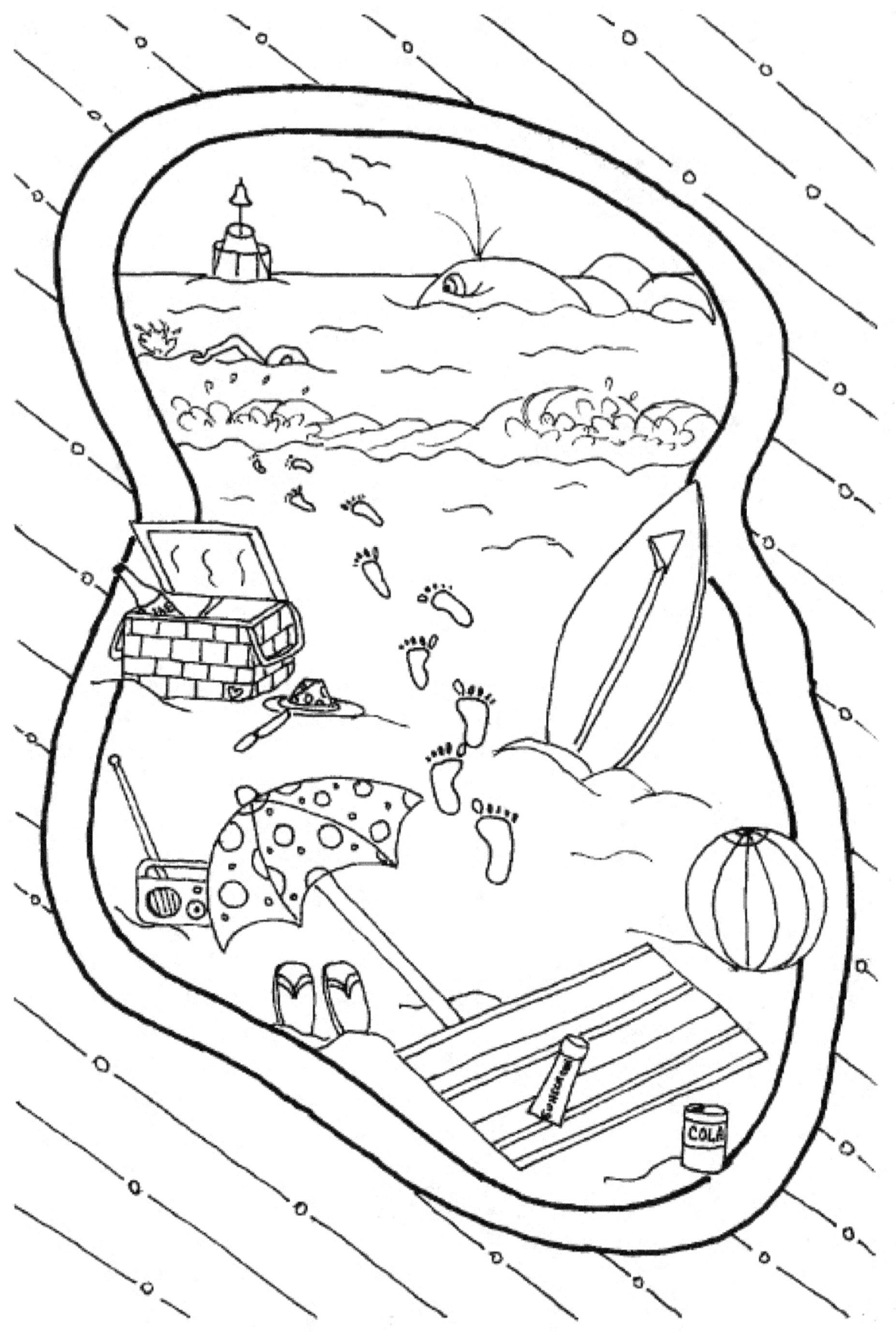

Facing Page:
"Mirror, Mirror"

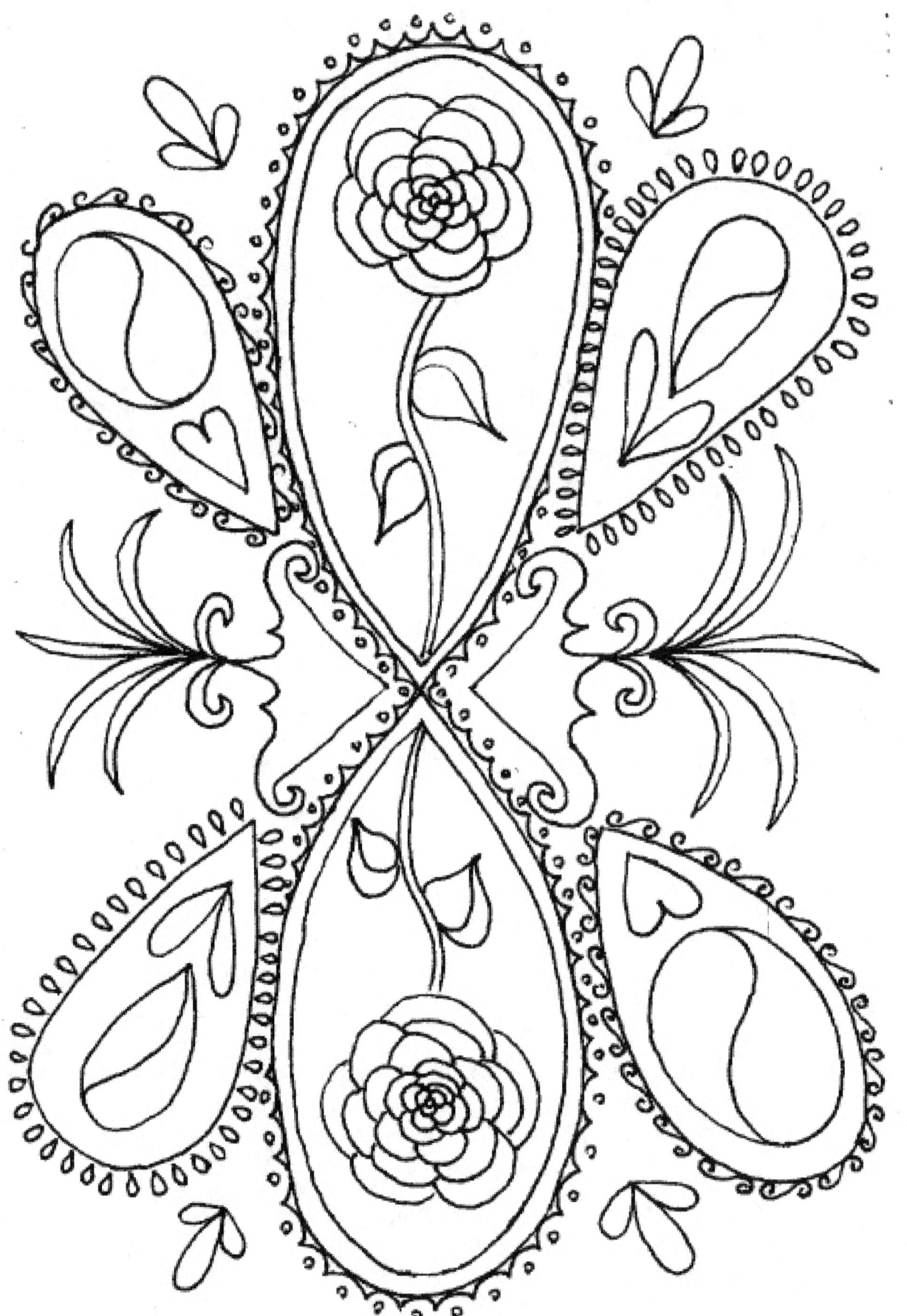

Facing Page:
"Mighty Mouse Hunter"

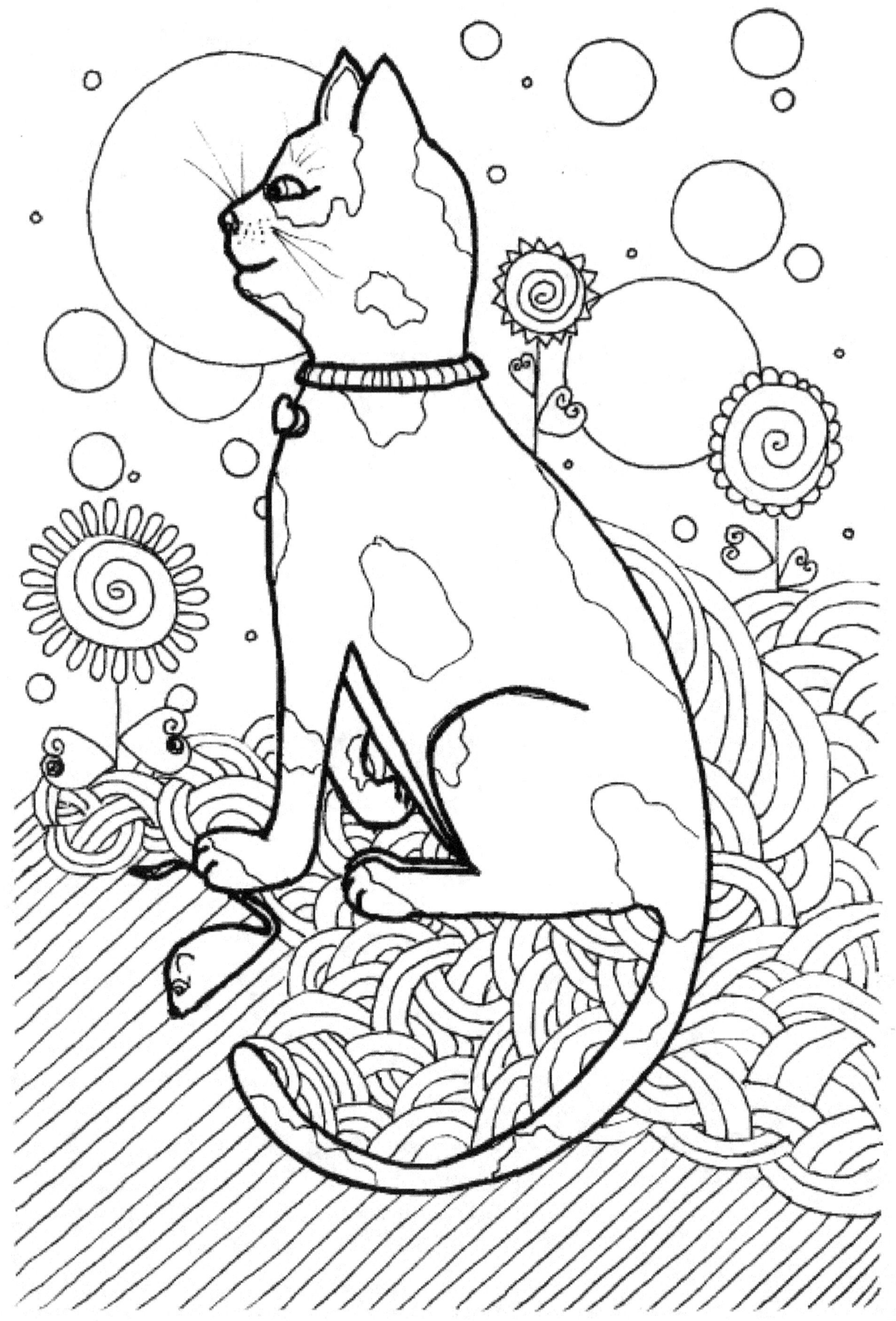

Facing Page:
"Life Begins"

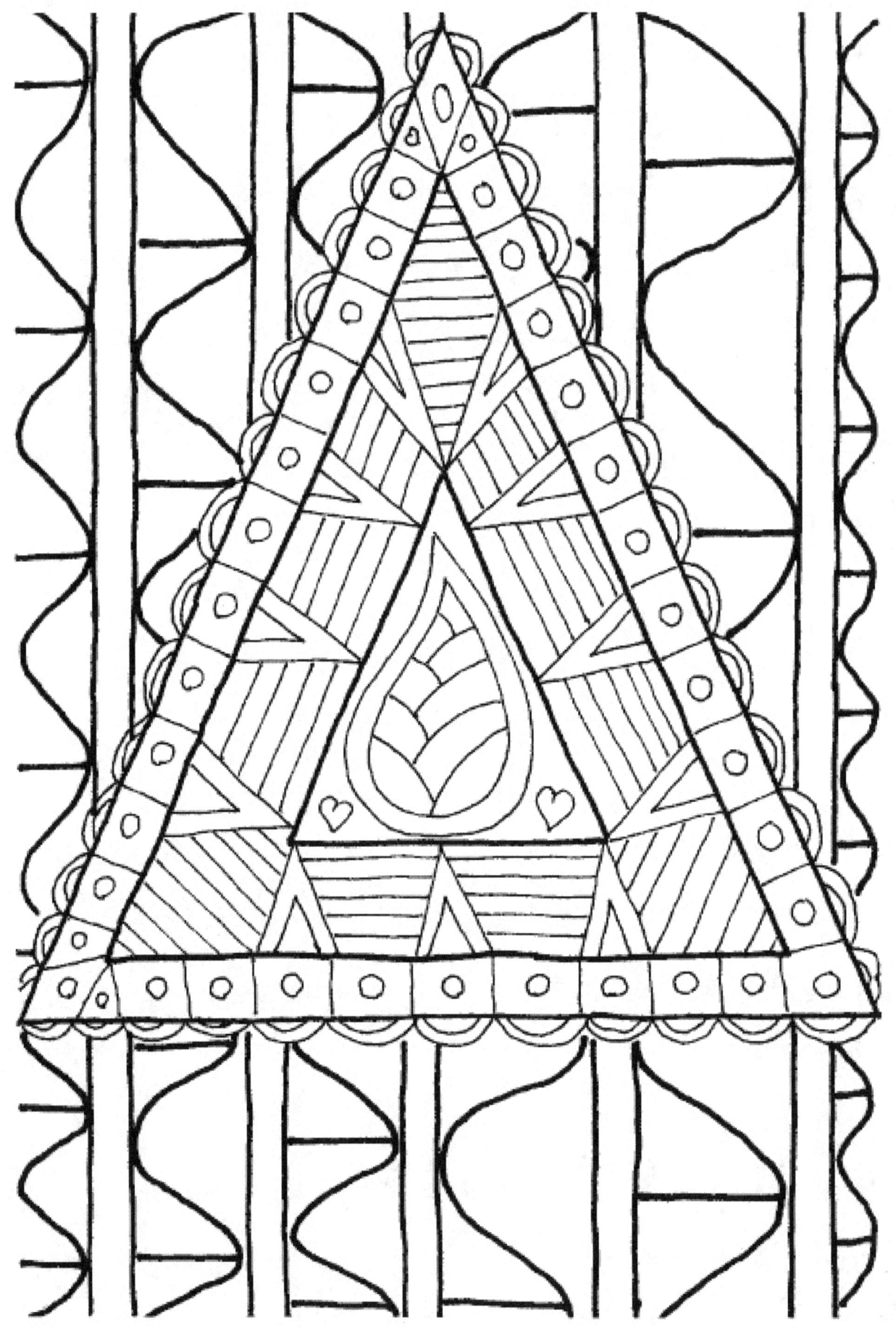

Facing Page:
"Bumpershoots"

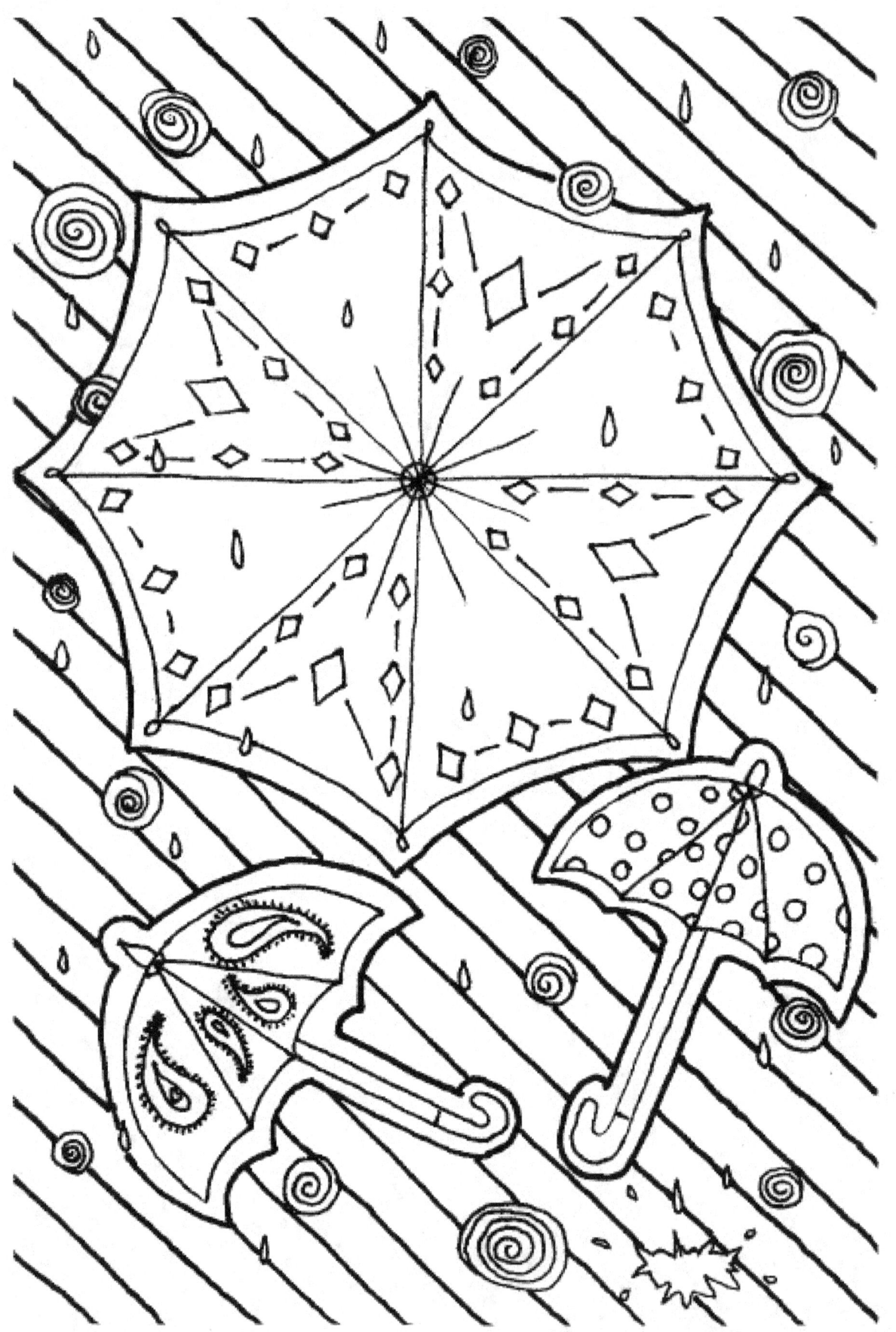

Facing Page:
"Grand Piano"

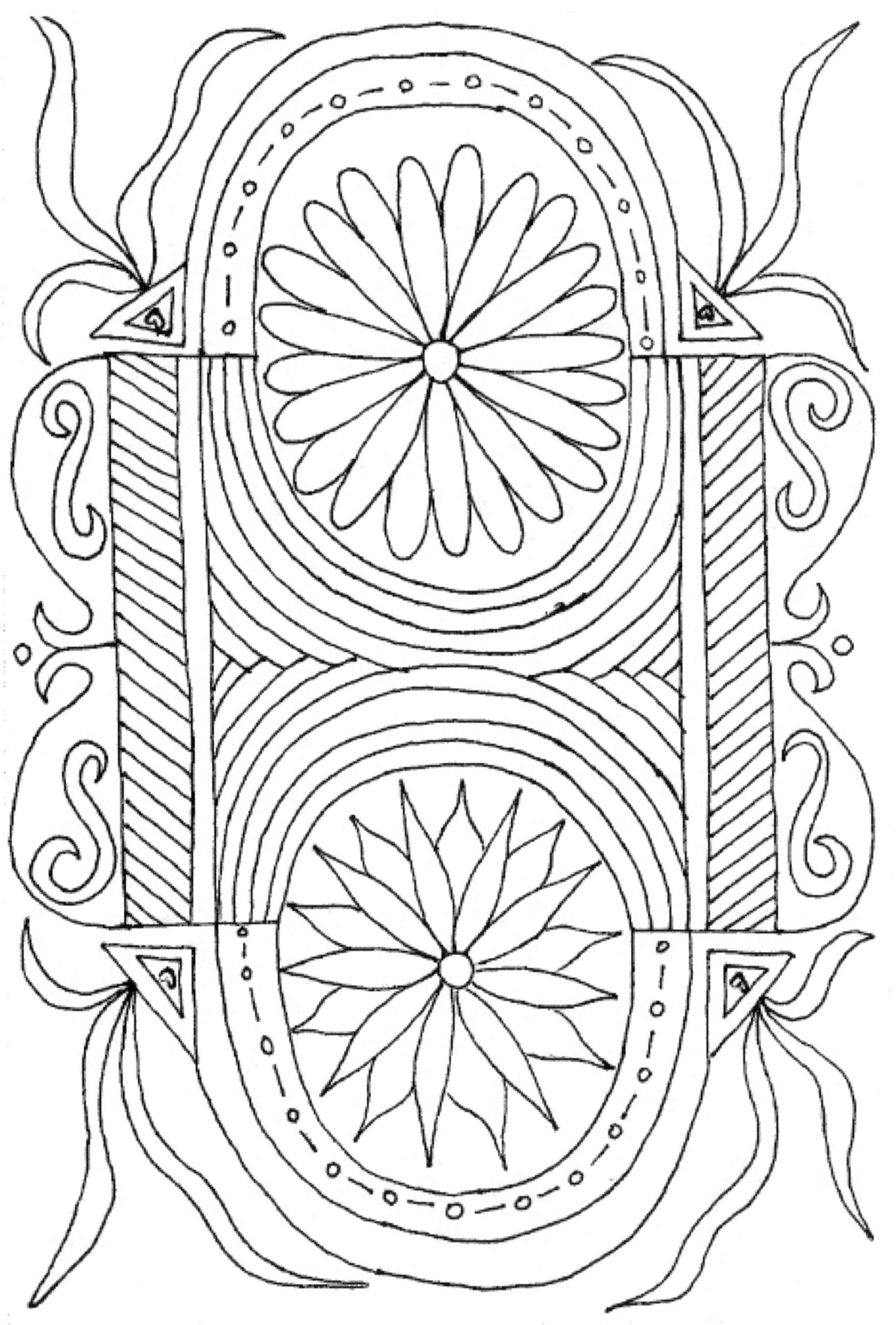

Facing Page:
"Celebration"

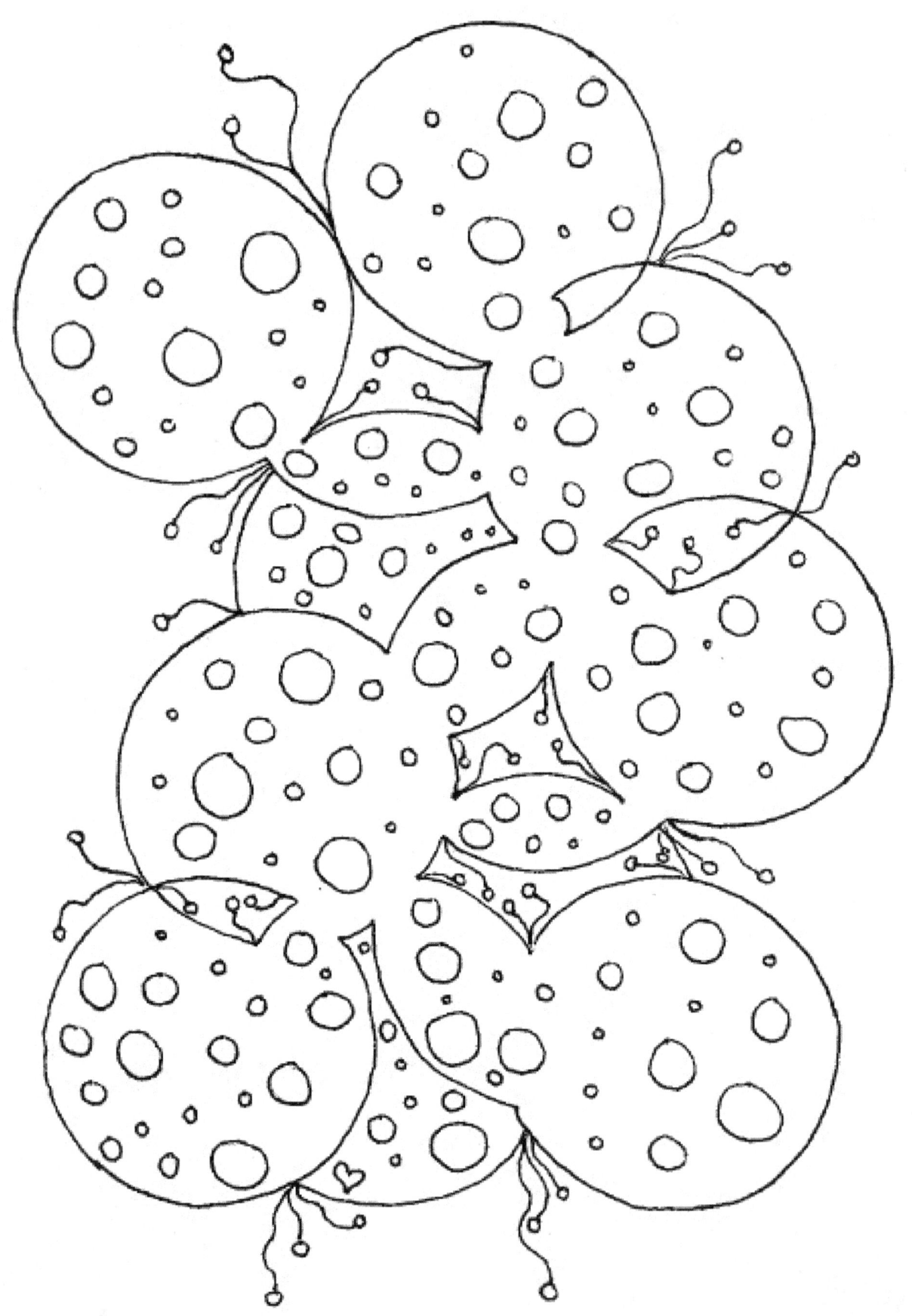

Facing Page:
"Quick, Eat It Before It Melts"

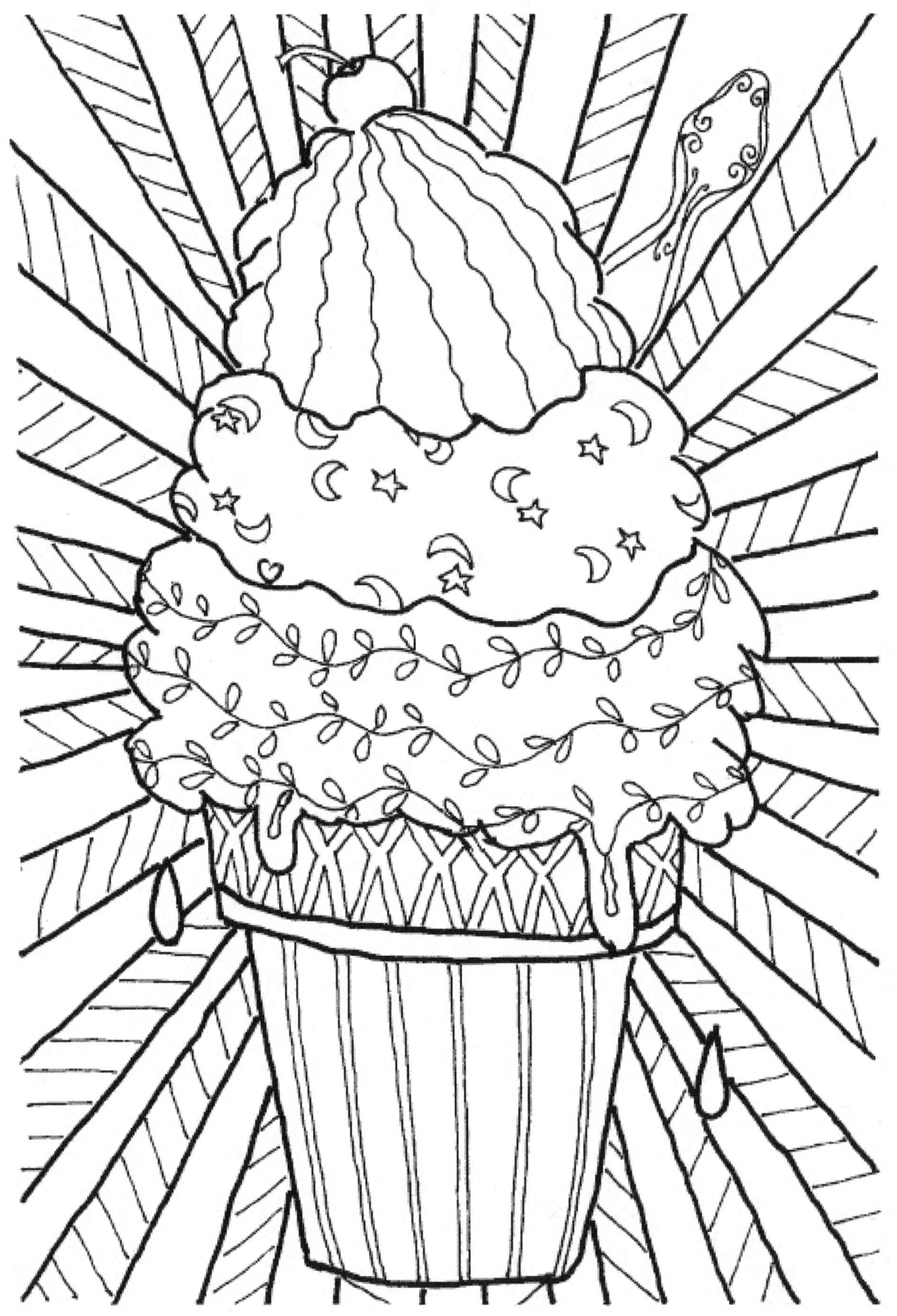

Facing Page:
"Love Bug"

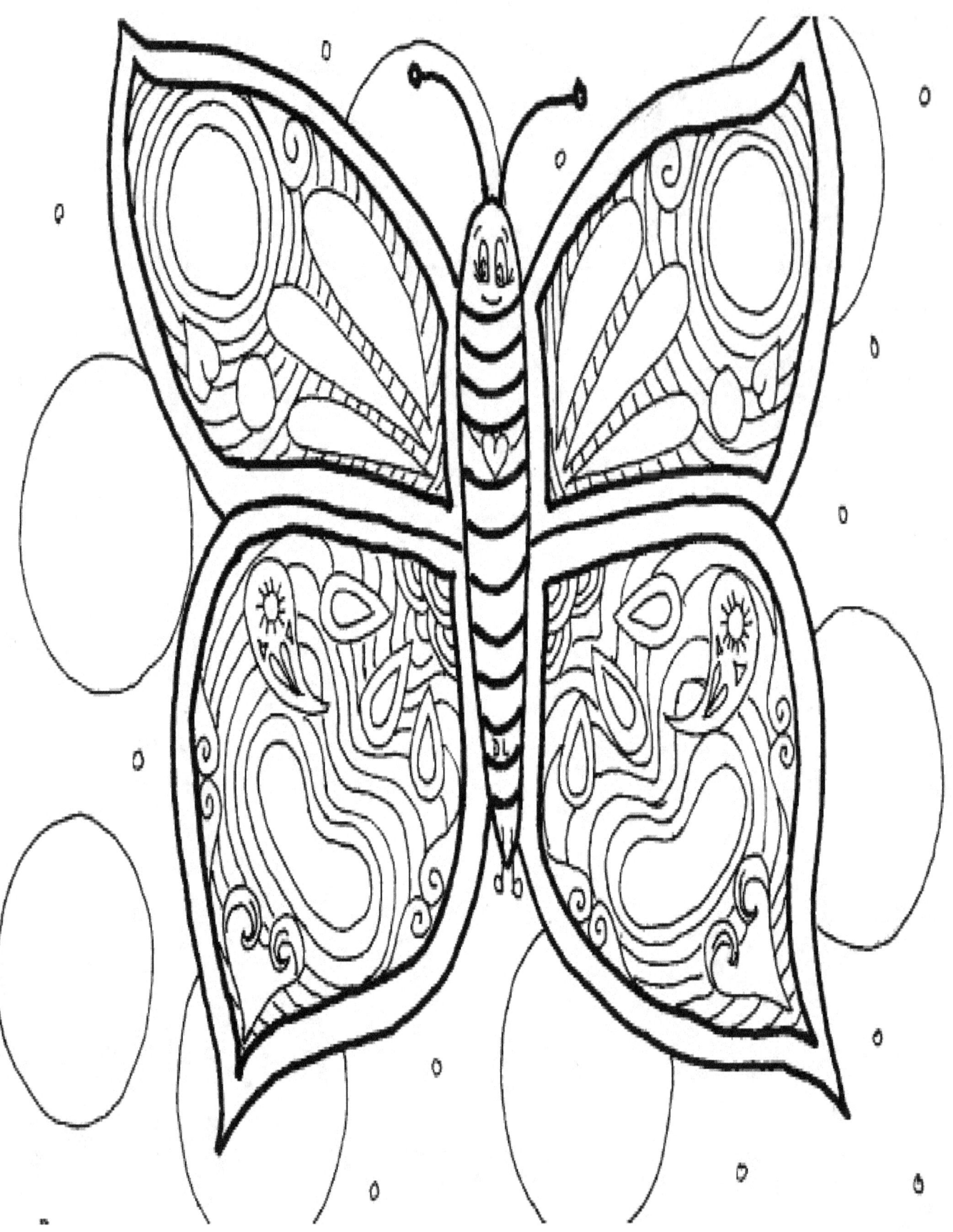

Facing Page:
"Hearts"

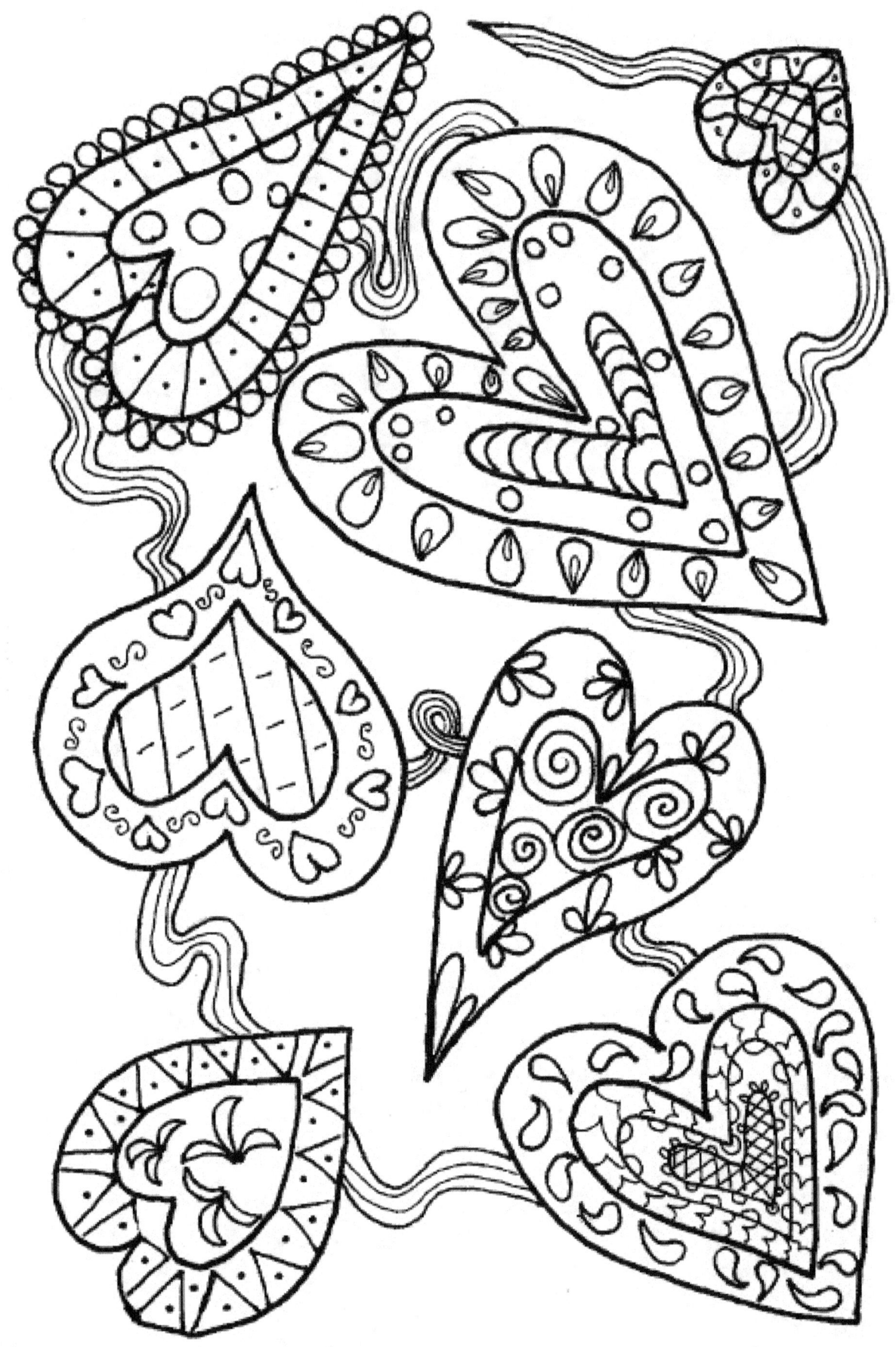

Facing Page:
"Window To A Life Forgotten"

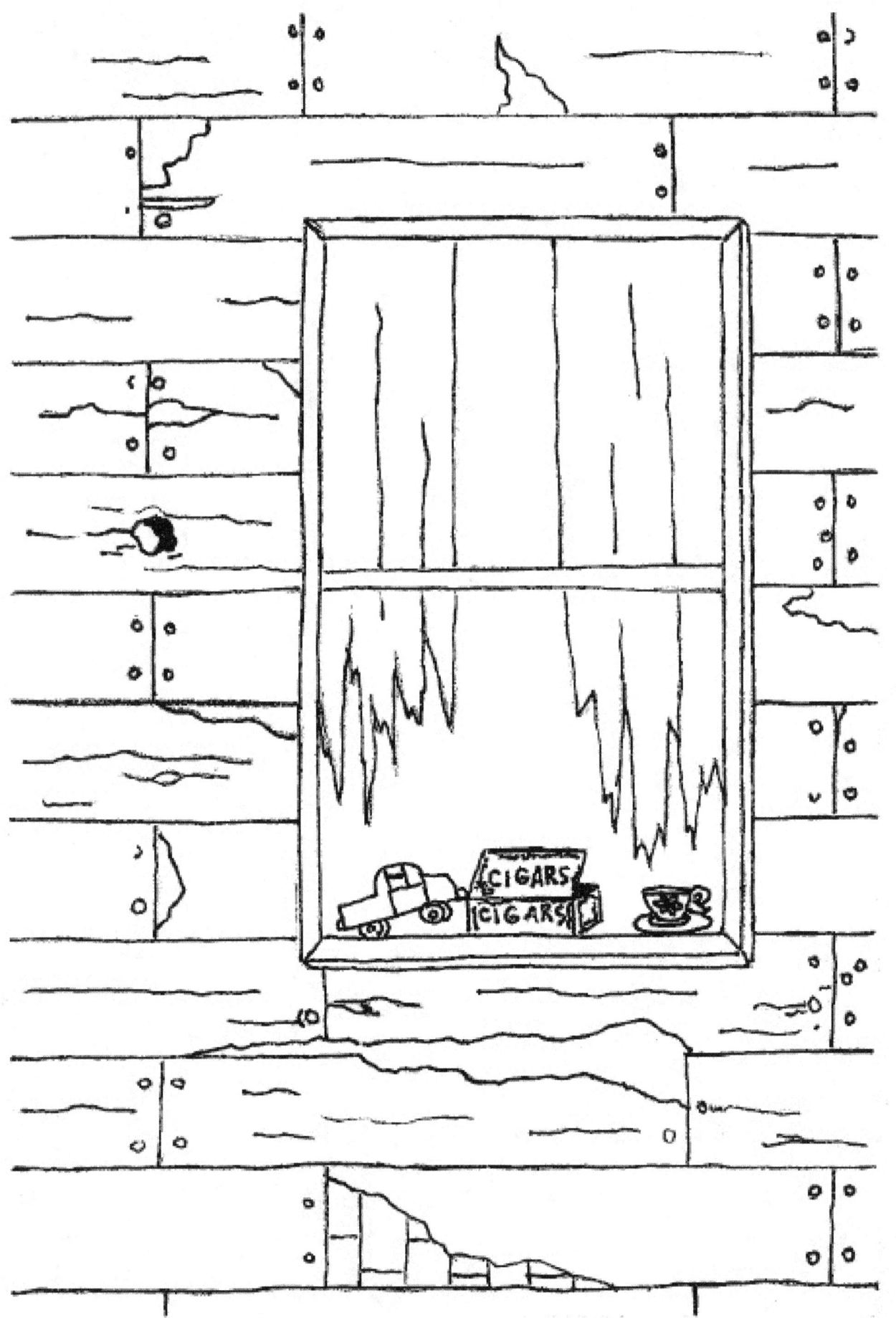

Facing Page:
"Fancy Fish"

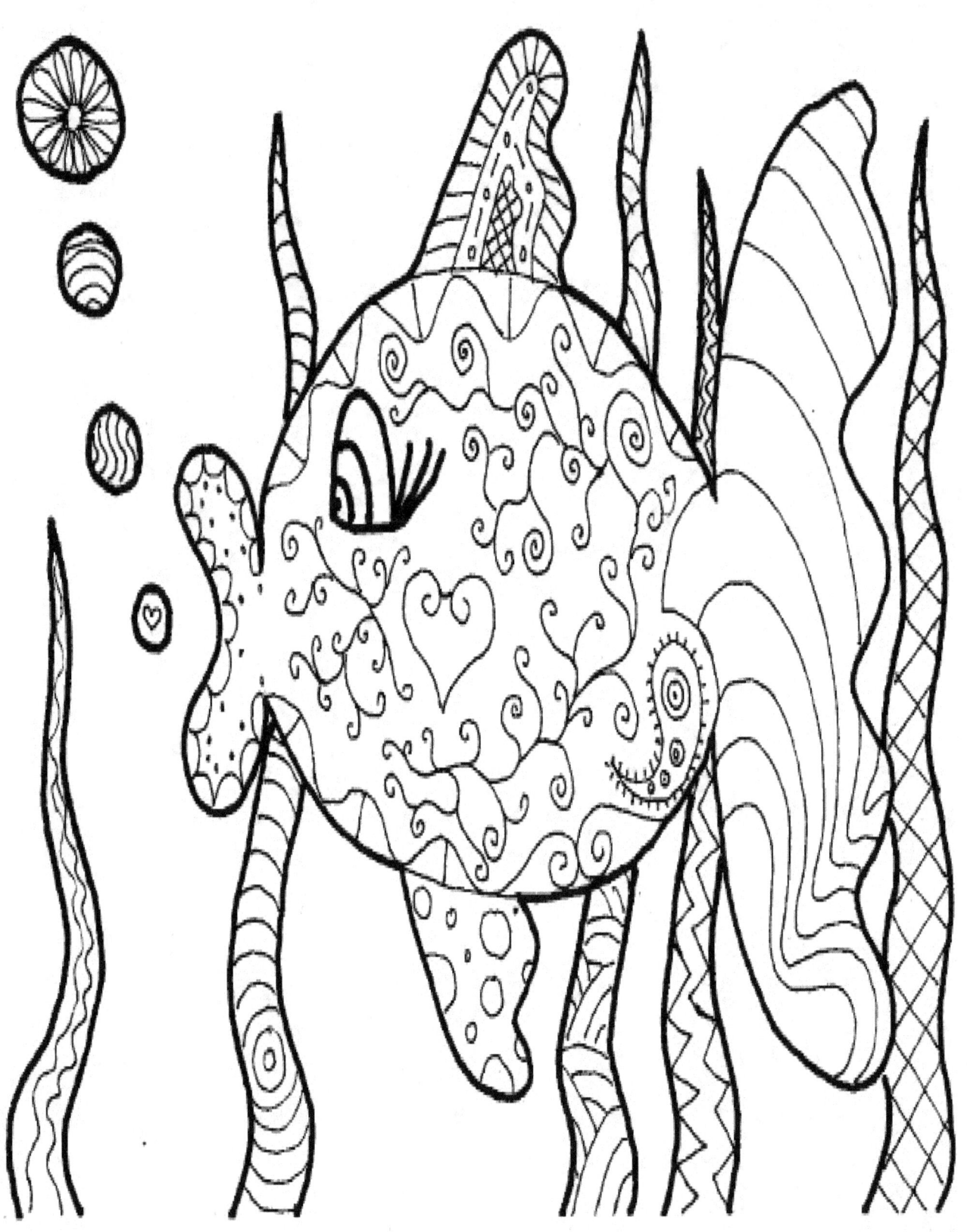

Facing Page:
"Oh, You Betcha"

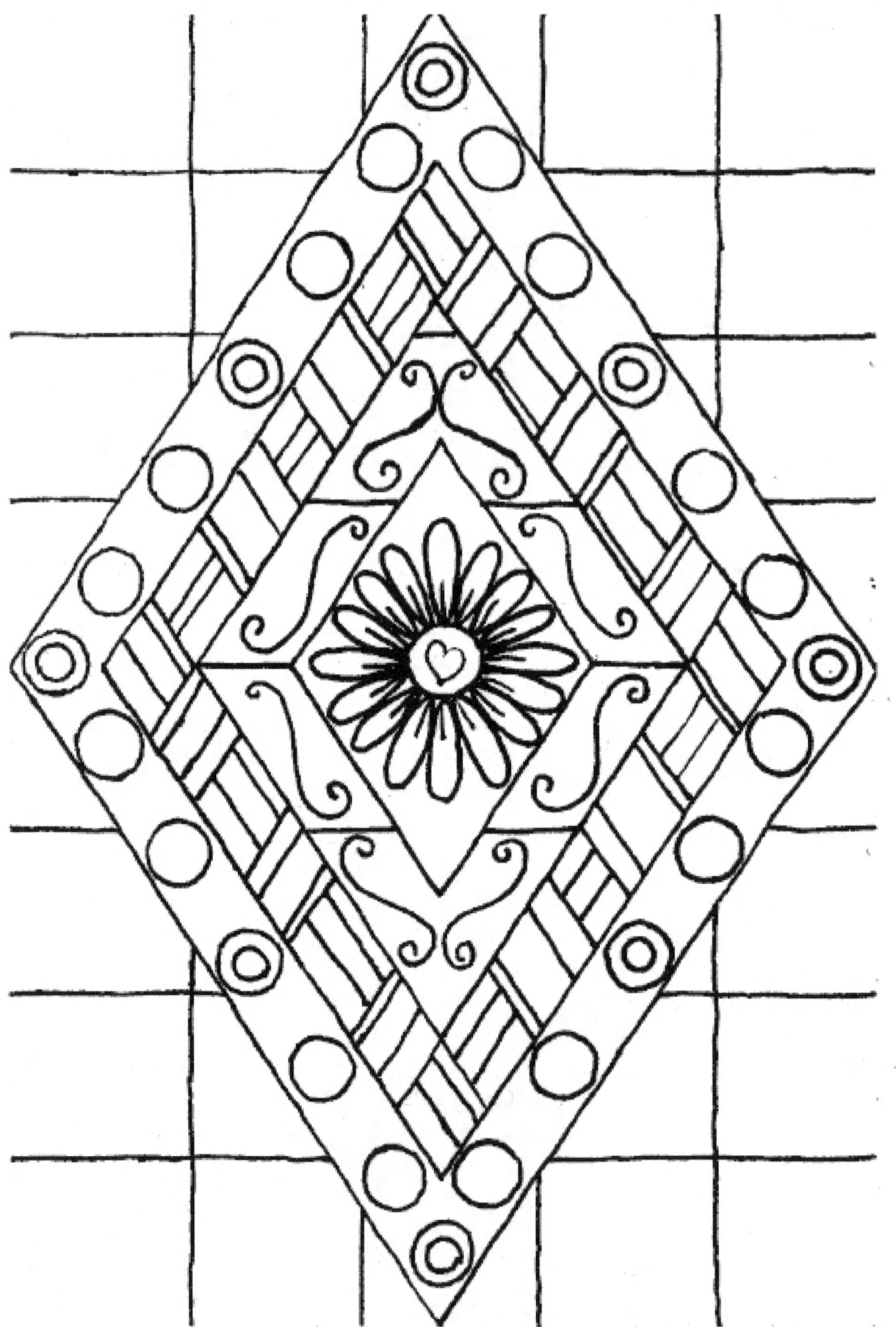

Facing Page:
"Fandango"

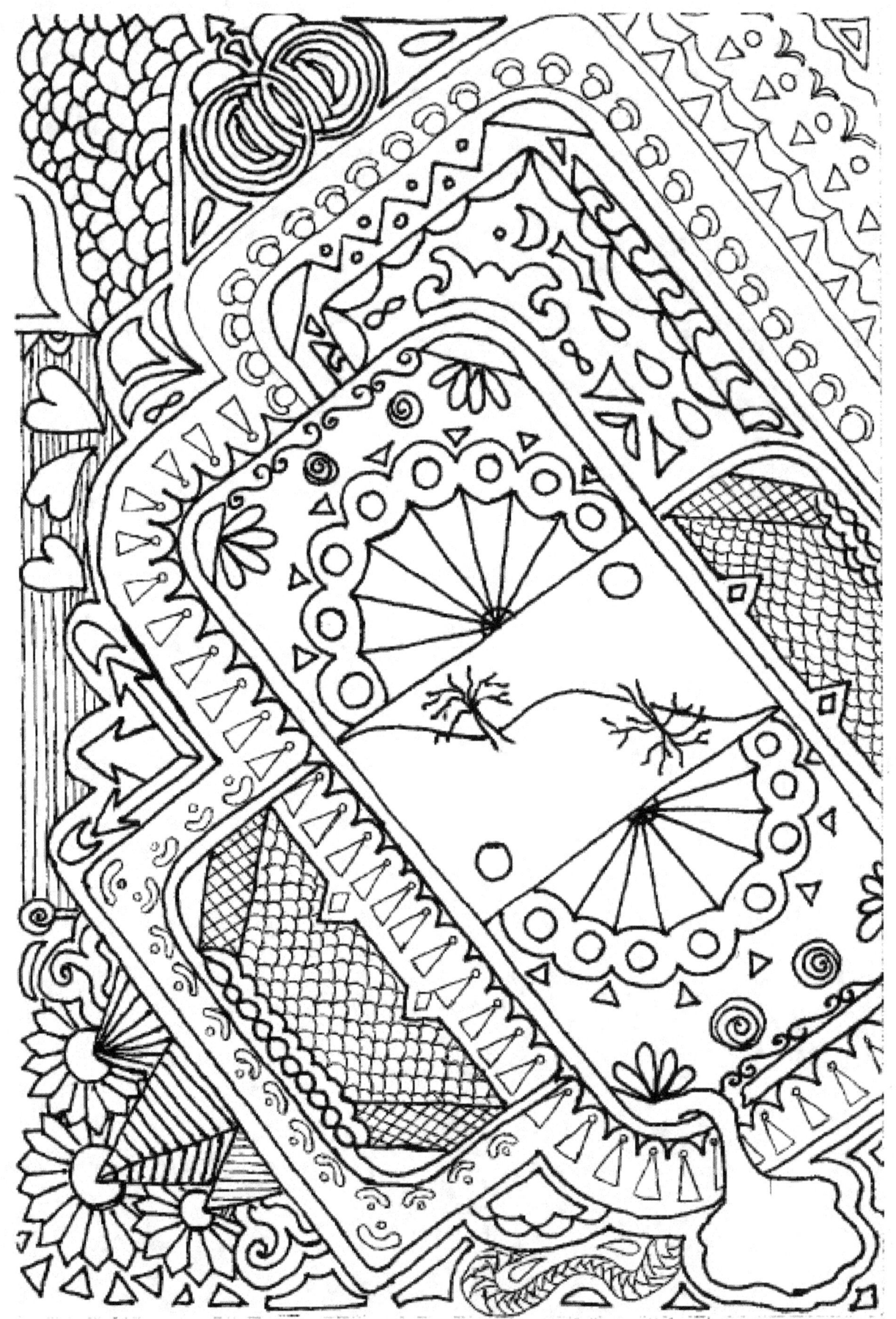

Facing Page:
"Hodgepodge"

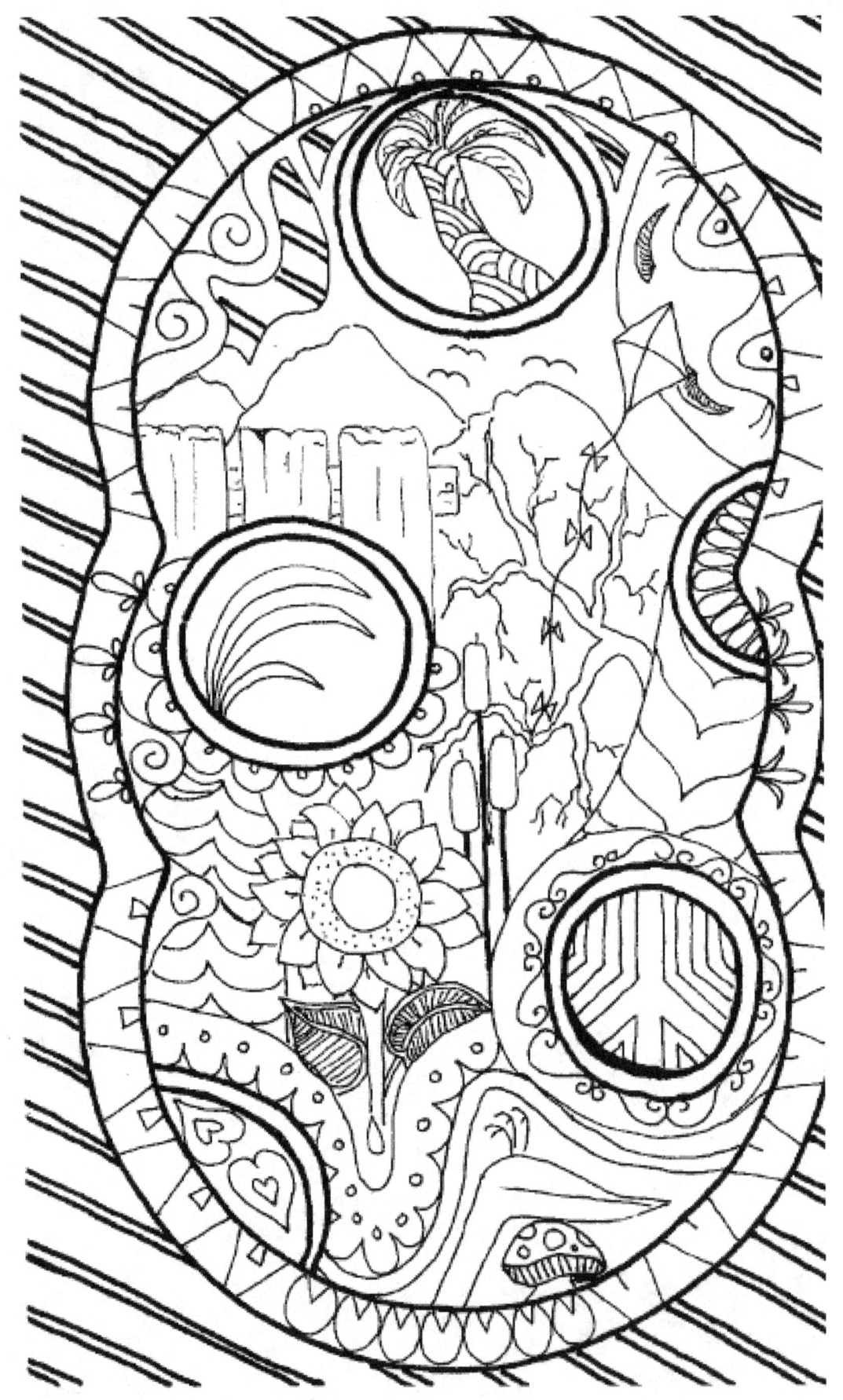

INDEX

Flower Power	5
It's Gonna Leak	7
Wishing Well	9
Tricycle	11
Kalaidascope	13
It's In The Kitchen	15
Sea Life	17
Daisies On Parade	19
Sound Bounces	21
Bella	23
Loved Locked	25
Plumeria	27
Test Pattern	29
Too True	31
Dual Waterfalls	33
With A Cherry On Top	35
Night And Day	37
Playful Assymetry	39
Shroomage	41
Flower Garden	43
Sunflower	45
Bubble, Bubbles, Bubbles	47
Crossed Diamonds	49
A Day At The Beach	51
Mirror, Mirror	53
Mighty Mouse Hunter	55
Life Begins	57
Bumpershoots	59
Grand Piano	61
Celebration	63
Quick, Eat It Before It Melts!	65
Love Bug	67
Hearts	69
Window To A Life Forgotten	71
Fancy Fish	73
Oh, You Betcha!	75
Fandango	77
Hodgepodge	79

About the artist

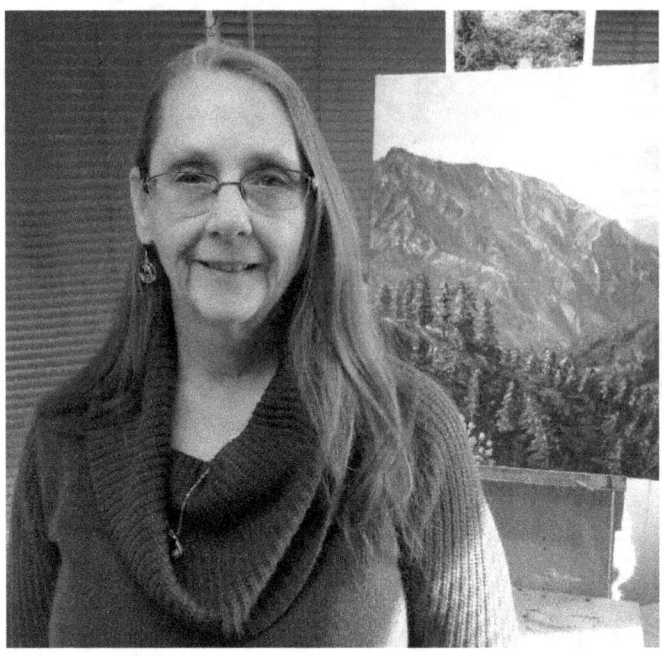

Renee Matter was born and still lives in Southern California with her husband, sister and two cats.

She has three grown daughters and two grandchildren. She has a business degree from the University of Phoenix and is a member of the Pomona Valley Art Association.

The mandalas in this book were inspired by many things; family, friends, quilts that she has made for her family and friends, and every day life. One of the mandalas ("Window To A Life Forgotten") is a simple drawing of an oil painting that Renee created from an old photo she took in the ghost town of Bodie, California.

Renee discovered at a very young age that she had a talent for drawing. In 2000, she took an oil painting class at an adult education center and fell in love with oils. She is largely self taught and continues to paint, draw, sew and just create every day.

www.ingramcontent.com/pod-product-compliance
Lightning Source LLC
Chambersburg PA
CBHW081209180526
45170CB00006B/2276